HOW TO CREATE ACTION, FANTASY AND ADVENTURE COMICS

TOM ALVAREZ

NORTH LIGHT BOOKS
CINCINNATI, OHIO

ABOUT THE AUTHOR

By age eight, Tom Alvarez knew he wanted to be a cartoonist, and, with his parent's support, the aspiring cartoonist's art education began. While studying art in college, Tom had the rare opportunity to study with Frank Giacoia, one of the best-known inkers and artists in comic history. After Giacoia's death in 1989, and while still a college student, Alvarez was accepted under the mentorship of artist Joe Giella. After graduation, Alvarez assisted Giella on many commercial cartoon accounts.

With Giella's encouragement and assistance, Alvarez began his own illustration company called Magical Graphics, on Long Island and has done animation- and adventure-style cartooning for companies that include Marvel Comics, Warner Brothers and Disney. Strongly influenced by Giacoia's 1950s "Sherlock Holmes" strip, Alvarez self-syndicated his own strip of the same name in 1993.

Now a resident of Port Charlotte, Florida, Alvarez continues as a freelance cartoon illustrator, while teaching art on the elementary school level. Alvarez is listed in *Who's Who in the East* and can be contacted on the Internet at alvaret@firn.com.

How to Create Action, Fantasy and Adventure Comics. Copyright © 1996 by Tom Alvarez. Printed and bound in the United States of America. All rights reserved. No part of this book may be reproduced in any form or by any electronic or mechanical means including information storage and retrieval systems without permission in writing from the publisher, except by a reviewer, who may quote brief passages in a review. Published by North Light Books, an imprint of F&W Publications, Inc., 1507 Dana Avenue, Cincinnati, Ohio 45207. (800) 289-0963. First edition.

This hardcover edition of *How to Create Action, Fantasy and Adventure Comics* features a "self-jacket" that eliminates the need for a separate dust jacket. It provides sturdy protection for your book while it saves paper, trees and energy.

Other fine North Light Books are available from your local bookstore or direct from the publisher.

00 99 98 97 96 5 4 3 2 1

Library of Congress Cataloging-in-Publication Data

Alvarez, Tom
 How to create action, fantasy and adventure comics / Tom Alvarez.
 p. cm.
 Includes index.
 ISBN 0-89134-661-9
 1. Comic books, strips, etc.—Authorship. 2. Comic books, strips, etc.—Technique. I. Title.
PN6710.A57 1996
741.5—dc20
 96-4305
 CIP

Edited by Diana Martin
Interior design by Brian Roeth
Cover design by Angela Wilcox
Cover illustration by Tom Alvarez

The permissions on page 141 constitute an extension of this copyright page.

METRIC CONVERSION CHART		
TO CONVERT	**TO**	**MULTIPLY BY**
Inches	Centimeters	2.54
Centimeters	Inches	0.4
Feet	Centimeters	30.5
Centimeters	Feet	0.03
Yards	Meters	0.9
Meters	Yards	1.1
Sq. Inches	Sq. Centimeters	6.45
Sq. Centimeters	Sq. Inches	0.16
Sq. Feet	Sq. Meters	0.09
Sq. Meters	Sq. Feet	10.8
Sq. Yards	Sq. Meters	0.8
Sq. Meters	Sq. Yards	1.2
Pounds	Kilograms	0.45
Kilograms	Pounds	2.2
Ounces	Grams	28.4
Grams	Ounces	0.04

DEDICATION

This book is lovingly dedicated to my beautiful wife, Doreen, for all of the patience and understanding she has shown me throughout my career.

ACKNOWLEDGMENTS

I would like to turn the spotlight over to a few key people who have helped me considerably in creating this book. Very special thanks goes to all the cartoonists who have unselfishly contributed their time, interviews and art to me. Thank you to John Romita for patiently helping me in a number of publishing ventures that have led up to and include this one. Thanks to Mike Morga for sharing the most brilliant ideas humanly conceivable. Thank you, Joe Giella, not only for being my teacher but for encouraging me through very difficult times. Thanks, Frank Springer, for your cooperation and suggestions. Thank you to Larry Lieber for more than just help with the book but also for better insight into comics. Thanks to Sy Barry for his guidance, wisdom and humor. Thank you, Al Scaduto, for your help, encouragement and terrific sense of humor. Thanks to Stan Lee for your unselfish contributions to this book. Thanks to Bunny Hoest, not only for your help on this book but for your professional insight into the little-known world of syndication. And thanks to Jay Kennedy for your contributions that have given the readers more understanding to the workings of syndication.

My hat is tipped to other key people in the production of this book. First is Greg Albert who went far beyond the call of senior editor and actually suggested the creation of this book. Thank you to Diana Martin, who's golden pen helped my words sing to the readers. And thanks to all the designers at North Light who have molded this book into its own work of art.

Within the creation of every book there are a few people that contribute to the sanity of the author, and this author needed a lot of contributions. I would like to thank Lou Trapani for his undying patience and suggestions, and thanks to Stephen Price for his last-minute art contributions and extreme knowledge of the comic book business.

No acknowledgment would be complete without thanking the people who simply encouraged and nurtured a simple little idea that flourished into this book. They are all the members of the Long Island Chapter of the National Cartoonists Society, known as The Burndt Toast Gang!

TABLE OF CONTENTS

THE KEY TO THE WHOLE AF

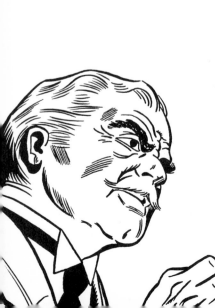

SIR ARTHUR CONAN DOYLE

CHAPTER ONE

LET'S CHAT

WELCOME!

By using this book, you will be taking a giant step toward one of the most creative and rewarding careers this country has to offer—writing and illustrating adventure comics. But there are a few things to discuss before you begin.

There is no other career in the world that is as difficult or as emotional as the Arts. When I say the Arts, I don't mean just visual art. Ask any artists, actors or musicians and they will tell you how taxing their jobs are. However, creating adventure comic books and strips is particularly difficult, but you can make a career out of it if you really want to. And that's the key!

To succeed in being an adventure cartoonist, you must want to be one deep down. You can't think, Well, I'll give this a try and if it doesn't work, I'll go into my cousin's business. That attitude won't even get you started in adventure cartooning. There must be a desire within you that constantly pushes you toward creating comics. This may be a desire that has been inside

you for years but you have only now decided to acknowledge. Or maybe your interest in drawing started at the age of eight and you are just now deciding what career path to take. Whatever your situation, listen to your inner voice. That voice will give you the drive to make it in any field. And drive is what you need.

The desire to be a comic artist can be very strong. You must harness your energy and focus it on your work and study. It takes a lot of motivation to be a good artist. If you have that motivation, you will succeed.

Motivation is the power within you that tells you to sit down and practice drawing when there is a ball game going on down the block or to wake up extra early on Sunday to get your drawing practice in so you can play in that game later in the afternoon.

What I am saying is, *it's all up to you!* You will get out of this book and your practice time exactly what you put into it. If you put in a lot of time, you will become a better

artist much more quickly than if you don't devote as much time to practice and study as you should.

It's very simple. On days that you have plenty of time, try to practice drawing for four or more hours. On days that you don't have much time, try to put in about two hours of practice. This may sound like a lot of time, but if you enjoy drawing and you work hard, the time will fly by as if hours were minutes. Remember, you can draw anywhere. If you have time in between classes or during study periods, draw then. If you take public transportation to work, draw during the ride, but watch the bumps. Squeeze in any drawing you can at any time during the day so when you get home at night, you can practice more or, if you wish, go to the movies and relax. Just as long as you get in your allotted amount of time to draw for that day.

It's extremely important that you work hard for the quality of your comics. As many cartoonists have said, "There is no excuse for bad drawing!"

To get the most from this book, you should first read one chapter through, ignoring the exercises and projects. After you have a good understanding of what is described in that chapter, get your supplies ready and reread the chapter, this time completing the exercises at the end. Don't skimp on the exercises; they're important. And don't stop practicing after you've completed the exercises. Take what you've learned and implement it in other drawings you create or ones you copy. Do this until you feel you have a good, strong understanding of the chapter's subject. Only then will you be ready to go on to the next chapter.

As you progress through the book, you can copy the artwork shown in each chapter or you can buy and copy comic books or strips that use the techniques described in these chapters. Whatever you decide to copy, *copy!* A good suggestion is to find an artist you really like, one whose work looks natural and realistic. Get a bunch of his work and copy from that. Make sure you have a good variety of his comics to work from so the lessons you learn will be enforced many times as you copy his work. Another suggestion is to choose one of the artists featured in this book. They have all had many years of experience and are considered the best in the business, and their work is readily available. But don't jump from one artist to another while you are learning; this could become confusing to you while your art is developing.

Contrary to popular belief, copying is *not* a dirty word. Unlike tracing, which helps in its own way but has extreme limitations, copying is an important tool in learning how to draw. At the beginning of my

Copying another artist's work is an important tool in learning how to draw.

comic education, friends told me never to copy anyone's artwork. I tried to draw from memory, and my work suffered. When I began to study art, and particularly comics, more in depth, I learned that every artist copies, both students and professionals. Think of your mind as a filing cabinet. If there is nothing in it, you can't take anything out. Once you study and *copy*, you are putting things in your mental filing cabinet. Then, when you need to draw something you have already drawn or copied, it will be much easier because you will be able to draw it from memory—it will be in your mental filing cabinet. If you have never drawn it before, you won't remember it. Throughout history, many artists have copied, and continue to copy, whether from photographs, other drawings or live models. Hey! Michelangelo copied. Why can't you?

A final suggestion: Don't worry about style! Style will develop as you draw and continue to improve. And some styles result from breaking the rules. For example, Todd McFarlane has a very noticeable style: His humans are elongated and elastic, which is fine, but his characters are not anatomically correct. McFarlane uses his style to put more action and adventure into his comics. However, that said, Todd McFarlane is an excellent artist. He could draw with precision if he wanted to, but he chooses to draw with more exaggeration. My point is, *you have to know the rules before you can break them.*

Just remember, there are three important steps you must follow every day of your life the minute you decide to become an adventure cartoonist: (1) Practice; (2) Practice; and (3) Practice! Now, get to work!

SHERLOCK HOLMES

Sir Arthur Conan Doyle

CHAPTER TWO

SUPPLIES AND EQUIPMENT

Let's face it, to learn how to draw, all you really need is a bunch of pencils and a lot of paper. But for completing an entire comic strip or book, you need a bit more. This chapter shows you the supplies that are used throughout the industry and explains their usage and, if needed, their proper care. Most of this equipment is necessary for you to properly finish any form of comic art.

PENCILS

Let's begin with the most basic tool for drawing: the pencil. I am sure you are familiar with the ol' standard no. 2 yellow pencil. Well, a no. 2 is actually only one of many types of pencils that are available. Although all brands of pencils are basically the same, their main difference is in whether the lead is soft or hard. The best way to understand pencils is by imagining a numbered horizontal line. The center of the line represents the average HB leaded pencil. As you move right along the line, the leads get harder in increments labeled 2H, 4H, 6H, all the way up to 9H. The higher the number, the harder the lead. In the same respect, on the opposite side of the center mark are the B leads, 2B, 4B, 6B, all the way up to 9B. The higher the num-

ber, the softer the lead. The standard no. 2 pencil is actually a 2B and falls in the softer lead category.

For simplicity, you should use three types of pencils in the beginning: a 2H, an HB and a 2B. These three pencils offer a great deal of drawing and shading flexibility. Avoid lead that is too soft, like a 4B, as this will cause a great deal of smudging and will be difficult to erase cleanly. Through practice, you'll figure out what type of lead you are most comfortable with. Your pencil work should be dark enough to see yet light enough for you to erase completely. Test the ones I have suggested and decide based on what you like.

Even though pencils seem like pretty basic purchases, your options extend beyond lead type. You can buy wood-encased, disposable lead pencils, which are perfectly fine, or the fancier mechanical or technical pencils, which can make your work easier to do. The mechanical pencil, also known as a gravity feed pencil, is basically just a holder with the lead inside it. The lead is as thick as the ones inside the regular pencils, and it needs to be sharpened by a special mechanical pencil sharpener.

A technical pencil is slightly different. It is similar to the mechanical pencil in its look and feel, but

it uses a different kind of lead. The lead in the technical pencil is very thin and doesn't need sharpening, which is a great time-saver. You just click the top and the lead advances. Since the leads are very thin, they break easily, so you must practice drawing with a light hand and not put a great deal of pressure on your pencil. Personally, the technical pencil with a 2H lead is the one I prefer.

No matter what type of pencil you are comfortable with, they all come with leads in varying degrees of hardness or softness, so choose your pencils wisely.

Keep in mind that the technical and mechanical pencils are more costly than wood-encased, disposable lead pencils, but they do have their advantages.

PAPERS AND BOARDS

Now that you have something to draw with, you need something to draw on. Your initial choice can be as simple as a sheet torn from your loose-leaf binder, but for our purposes, you should use something better.

For learning how to draw and for practicing throughout your career, the best paper to use is bond paper. Bond paper is a tightly woven fiber

paper, has a very smooth surface and comes in different weights, which is how paper thickness is indicated. For example, 16-pound paper is about as thick as regular typewriter paper, while 32-pound is thicker and will withstand more erasing and corrections—not that you will make that many mistakes. So get a couple of 11″ × 14″ pads of bond paper, and be prepared to use them up quickly.

The paper you will use later on, when you begin to create finished comic pages and strips, is called bristol board. Bristol board is not a board but a paper. It comes in four thicknesses—one-, two-, three- and four-ply—as well as two different types of drawing surfaces. You can choose between plate (smooth) surface and kid (rough) surface. The kid surface is also known as vellum surface because it has the surface texture of vellum paper. You will want to begin with a 14″ × 17″ pad of two-ply, plate surface bristol board.

Two other pads to have handy are regular tracing paper and vellum trace. Vellum is a thick tracing paper and is better quality than standard tracing paper. Regular tracing paper is used for tracing objects and figures you might want to use in different ways in your comics, while vellum trace is used to practice different inking styles. Because of its thickness, vellum will hold up better with ink, yet it is still transparent enough to see the pencil lines underneath.

ERASERS

For those times you change your mind or make (ahem!) mistakes, there are a variety of different erasers. Not all erasers are used for the same purpose. Yes, they are all created to erase but not in the same fashion.

The first type of eraser is the kneaded eraser and is very much like clay. You can knead it into different shapes for getting into tight corners or knead it into one large blob to erase a big area. This eraser has a bit of mystery to it since few people understand how it's supposed to be used. Of course it is used to erase pencil lines, but the primary purpose for the kneaded eraser is to erase the lighter, sketchy lines while keeping your darker, finished lines in full view. Remember, if you use a soft-leaded pencil, this type of eraser will smudge the lead on your paper.

One good thing about the kneaded eraser is that it is very therapeutic. While you are contemplating what you should draw next, you might find yourself kneading the kneaded eraser. This is helpful because it keeps your hands busy while your brain is in high gear.

The most widely used and best eraser for the job is a white vinyl eraser. It erases completely and cleanly and comes in many forms. You can get a vinyl eraser in the form of a pencil for those tight areas, or you could be high tech and use an electric eraser with vinyl eraser inserts. The electric eraser can be convenient but costly.

There are a great deal of other types of erasers—far too many to cover here. The kneaded and the vinyl are the most popular; however, it is up to you to judge which one works the best for your needs. Since erasers are cheap, pick up a bunch of them and try them all. When you find a particular one that works well for you, buy a number of them to have on hand.

INK AND INKING TOOLS

To make your drawing's pencil lines reproducible in newspapers

and comic books, you must ink them. Choosing an ink for the inking process depends greatly on the tool you are using and what you want the ink to do. It is not surprising to see an inker combine three or more different types of ink with different tools to complete one comic strip or page. The most widely used ink is called India ink. This is a basic black ink that is medium in consistency. It flows well in a pen as well as with a brush. The most widely used India ink is Higgins India Ink. There are many other ink manufacturers; it is just personal preference as to which one you find to be the best for you.

Since different types of inks suit different tools, I will explain what ink is used as I describe the tools.

SABLE BRUSHES

The first and most professionally used inking tool is the sable brush, which most of all the old comic masters still use today. The brush is the most difficult utensil to master, but once you do, your inking will glow with quality and professionalism. No other tool gives the finished look achievable with a sable brush. But not only are they difficult to master, they also can cost a small bundle because the bristles are made from Russian pig hair.

One of the best brushes available is the Isabey Kolinsky sable brush. Brush sizes no. 2 and no. 3 are important to have because these two give you the widest range of inked line variation. (The numbers refer to the amount of bristles on the brush. The smaller the number, the fewer the bristles.) Other top quality sable brushes are the Winsor & Newton Series 7. If the Isabey brushes aren't available, the Winsor & Newton Series 7 in sizes no. 2 and no. 3 are a good replacement.

Top quality brushes can cost from fifteen to thirty dollars, depending on where you buy them. If money is tight, there are alternatives. Winsor & Newton Series 707 brushes, sizes no. 2 and no. 3, are about half the price of the Series 7s. These are great to learn with, too.

The most important thing to remember about working with brushes is that *you* determine how long they last. India ink eats away at the bristles of sable brushes, so if you wash them thoroughly each time you use them, they will last a very long time.

As for an ink to use with brushes, Higgins makes an ink called Black Magic, which is a thick, dense black. You can't find an ink darker than Black Magic. It works well with brushes, but only brushes, as it clogs easily if used in any other type of inking tool.

DIP PENS

Another inking tool is the dip pen, which is exactly what it sounds like. This tool uses nibs of different sizes that fit into a pen holder. You dip the nibs into the ink and then ink your pencil drawings.

The best pen nibs to use are the no. 1290s by Gillott. They are inexpensive and flexible and give you a variety of line thicknesses. The pen nib is much easier to use than a brush because it is easier to control, but it does take some practice to get good at it.

The type of ink to use for dip pens is called Engrossing ink. Engrossing ink is the blackest ink you can get that flows freely and won't clog your pen nibs. The same care applies to the pen nibs as to the brushes: Always wash your pen nibs when you are finished inking, and they will last you a long time.

MARKERS AND PENS

The two remaining tools are the felt-tip marker and the technical

pen. The markers don't need any ink, and you can buy them in a variety of sizes. The larger sizes are good for filling in large black areas, while the fine and extra fine are used for inking the penciled lines. The technical pen also comes in a variety of sizes. A few good sizes to start off with are 4×0 (.18mm), 00 (.30mm) and 1 (.50mm). In the technical pen, you must put the ink into a special cartridge inside the pen. Use either India ink or Engrossing ink. Both work equally well, but the Engrossing ink won't clog your pen as much.

The problem with markers and technical pens is that they are extremely rigid. You can not vary your line widths, which tends to make your work look a little too technical and static. But, with practice and imagination, you can create a certain "look" that you can only get with either of these tools.

GETTING STARTED

It is best to start with the dip pen for line variance and an extrafine felt-tip marker for stable lines. After you have mastered these, begin to experiment with the sable brushes and technical pens. You will easily see your inking quality improve as you practice.

TECHNICAL TOOLS

The ruler is the most common sense tool you can use. You can't draw a straight line without one. When you buy a ruler, get one that is made out of stainless steel, as its measurements are more accurate than a wooden ruler's, and it will last longer than wooden or plastic rulers. Also, try to get a ruler with an inking edge, which is an edge that does not rest on the paper. A ruler with an inking edge has a slight undercut to it when you look at it from the side. Then, when you use the ruler for inking, the ink doesn't drip underneath the ruler, spread out along the length of the tool and smear on your paper.

Another fantastic tool that isn't widely known is called the rolling ruler. This is a ruler that has a long tube on one side, which acts as a wheel. It glides back and forth with precision. The rolling ruler comes in handy when drawing and inking numerous parallel lines for such things as buildings, furniture and any other object that requires straight lines. As with the ruler, if you use the rolling ruler for inking, make sure it has an inking edge on the measurement side. If it doesn't (and many of them don't), you can easily make one by gluing something on the underside of the ruler edge to lift it slightly off the paper.

The T-square and the triangle are two tools used in almost every form of graphic art, and comics is no exception. The T-square is great for creating horizontal and parallel lines with complete precision. The triangles, alone or in tandem with the T-square, make 30°, 45° and 60° diagonal lines and 90° vertical lines. It is not often you will be using the angles of the triangle for much unless you are drawing futuristic or technical settings or equipment. When buying these tools, purchase a T-square of at least twenty-four inches in length (metal ones last longer but are more expensive), a 45°-45°-90° triangle and a 30°-60°-90° triangle.

The final "technical" tool you need is a compass. This is used to create perfect circles when penciling or inking. You probably saw the cheap ones while in grade school. These are fine for kids, but you need reliability now. A decent compass runs a little over twenty dollars but is well worth it. When you buy one, be sure it comes with an inking extension.

SETTING UP A WORK SPACE

An important thing that not many people think about is a place to work. If you have the room, you could set up a separate "studio" to work out of, but most people don't have that luxury available to them. So your best bet is to find an area of the house where you can work without being disturbed.

Now that you know where you are going to work, you have to decide what you will work on. A drawing table, a drafting chair and a desk lamp, are good pieces of equipment to have but are also expensive. All you really need is (1) a table and drawing board to work on; (2) a comfortable and sturdy chair; and (3) adequate lighting. You don't have to spend hundreds of dollars for this equipment to practice drawing. In fact, all you may need to buy is an inexpensive, smooth drawing board 16" × 21" or larger. Then just sit at a table, rest your drawing board in your lap and lean the top of the board against a table. This creates the proper slope to work on and the clean, smooth surface you need for practicing.

Eventually, after your career in comics has begun, you might want to consider buying the more professional furniture. It is better for your body if you work on a table that is more sturdy and a chair that is manufactured with this type of work in mind.

Whatever you decide to use, just make sure you are comfortable and you are working with the proper amount of light.

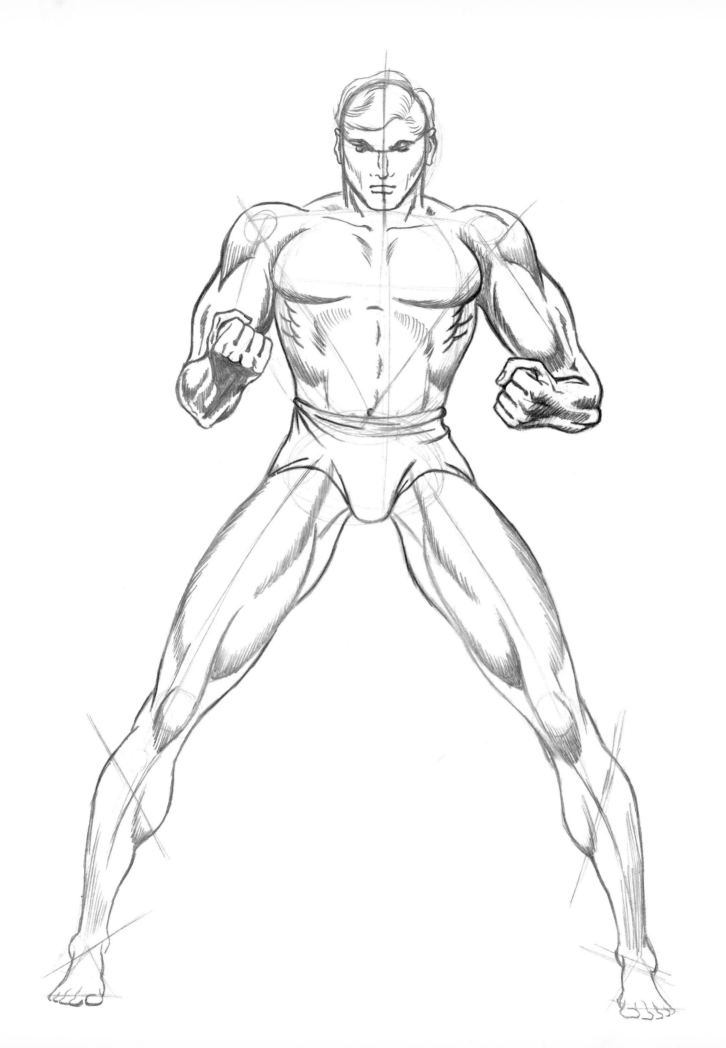

HUMAN ANATOMY

This is it! This is where we get into the heart of the comics—the anatomy.

The human figure is the most important part of comics. Without figures, there would be no comics. Everything revolves around people and the things they say and do. That's why the anatomy is so important.

You'll notice that this chapter, which covers both male and female figures, puts little emphasis on heads and hands. These append-ages are particularly important, so you will learn about them in a separate chapter.

The beginning of this chapter may seem boring and tedious, but I assure you, it is of the utmost importance. If you follow through with the examples and exercises, you will become a better artist faster than if you skipped right to the figure drawing. You will also have a better understanding of how to draw everything else.

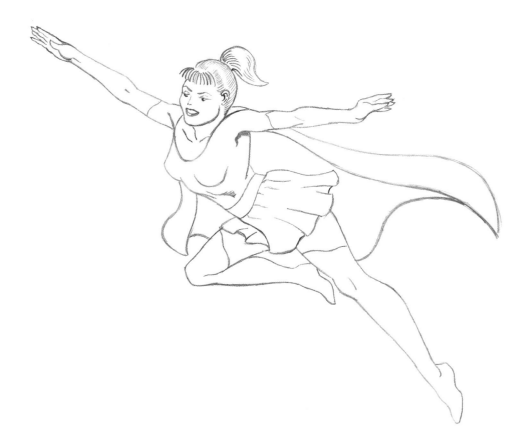

ANATOMY'S THREE BASIC SHAPES

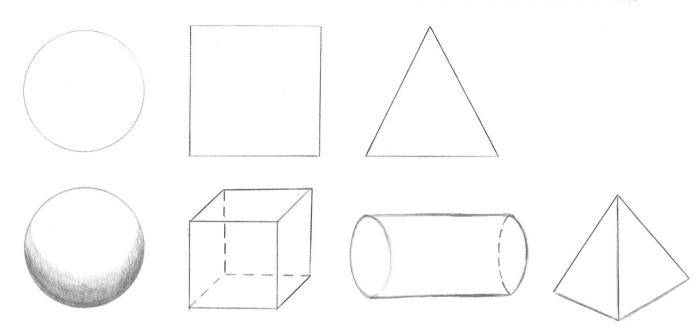

If you look around, you'll notice that everything in the world is made up of three basic shapes: the circle, rectangle (square) and triangle. No matter what you look at, you will find one or more of these shapes. Oh, sure, there will be things that are more elaborate than merely a circle, but the circle is the foundation for that object. That's an important rule to remember in drawing. Look at someone's head. It's a circle. How about the torso? That's a square. The legs and arms are tubes, which are just rectangles with rounded edges. So you see, as easy as it is for me to explain it to you is as easy as it is for you to draw. Get your bond paper pad and HB pencil and follow along.

As you may remember from when you were learning how to write in cursive (script), there were certain exercises the teacher had you perform so you learned to write correctly and neatly. Those exercises were for your benefit and for the benefit of your writing. Well, now I have some similar exercises that will benefit you and your art.

Even the human body can be broken down into the three basic shapes: circle, square and triangle.

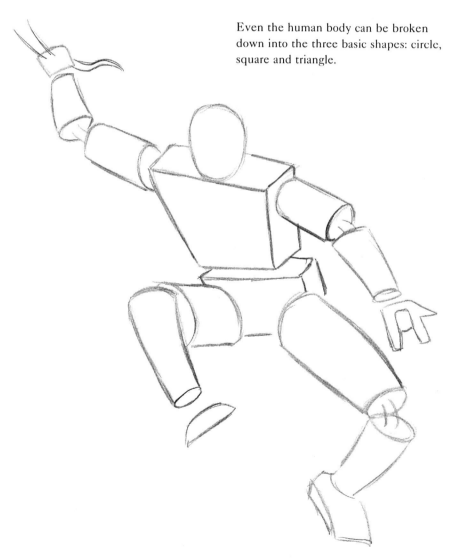

See how many basic shapes you can find in this comic page.

Exercise:
CIRCLE SKETCHES

I want you to take about an hour to draw circles. Not just any circles—these circles are connected. Start at the top of what will be your circle, circle around to the left, then up to the top again. Continue the circle over and over again while drawing on top of each previous circle. Don't put much pressure on the pencil. In fact, draw so lightly that you can just make out the lines you have drawn. Continue to fill up pages from your pad, using the back of the sheets as well. When you draw these circles, try not to rush them just to get it over with. Draw them quickly, like sketching, but concentrate on trying to keep them round. As you sketch rapidly, remember to use your entire arm to draw. Move from the shoulder, not the wrist. Don't allow your hand to rest on the paper as you draw. Glide over the paper. Using your entire arm lets you draw any size you want. You can draw a circle as small as a dime or as large as the entire sheet of paper. Continue to draw the circles until you feel you are able to sketch out an almost perfect circle with few loops.

All of this is a good way to warm yourself up for drawing and to get used to sketching quickly and accurately. When you begin to draw each day, you should get into the habit of sketching out at least one full page of these circles to get you ready to draw.

Now that you've worn yourself out with circles, let's get into something that is a bit more exciting.

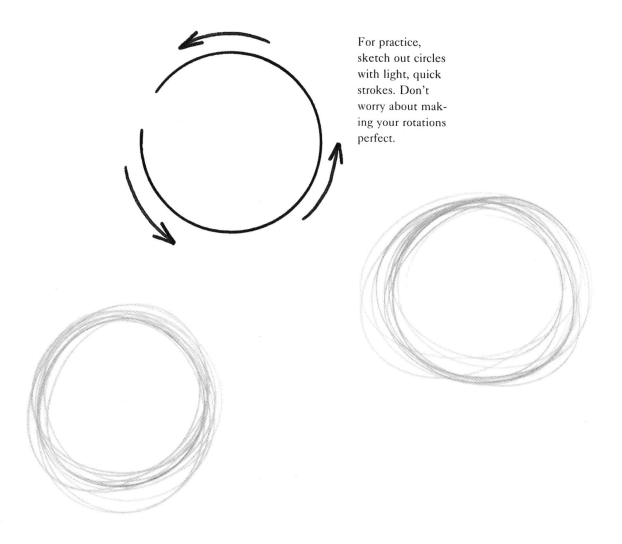

For practice, sketch out circles with light, quick strokes. Don't worry about making your rotations perfect.

HUMAN PROPORTIONS

Study the figure on page 22. This finished drawing shows that the average male figure is seven heads tall. A head, in anatomy drawing, is a form of measurement, just like an inch is. To keep the figures you draw looking correct, or, as it's properly called, in proportion, make sure the size of the head is correct compared to the size of the body and vice versa. Since superheroes are larger and more powerful than the average human, they must be drawn that way. The figure of Captain Atomic shows that a superhero is eight heads tall. This size increase gives the illusion of power and strength to the readers of your comics.

Just as the body is measured for height, so are the shoulders. On the average man, the shoulders are three heads wide, while the superhero's shoulders are three-and-a-half heads wide.

Women use the same rules, but their heads are slightly smaller than the men's. This causes the entire female body to be slightly smaller. In contrast to the muscular and angular male physique, female figures are drawn smooth and curved.

On all human figures, the hand, when the figure is standing, falls in the middle of the thigh, while the elbow lands slightly above the waist.

MALE FIGURE PROPORTIONS

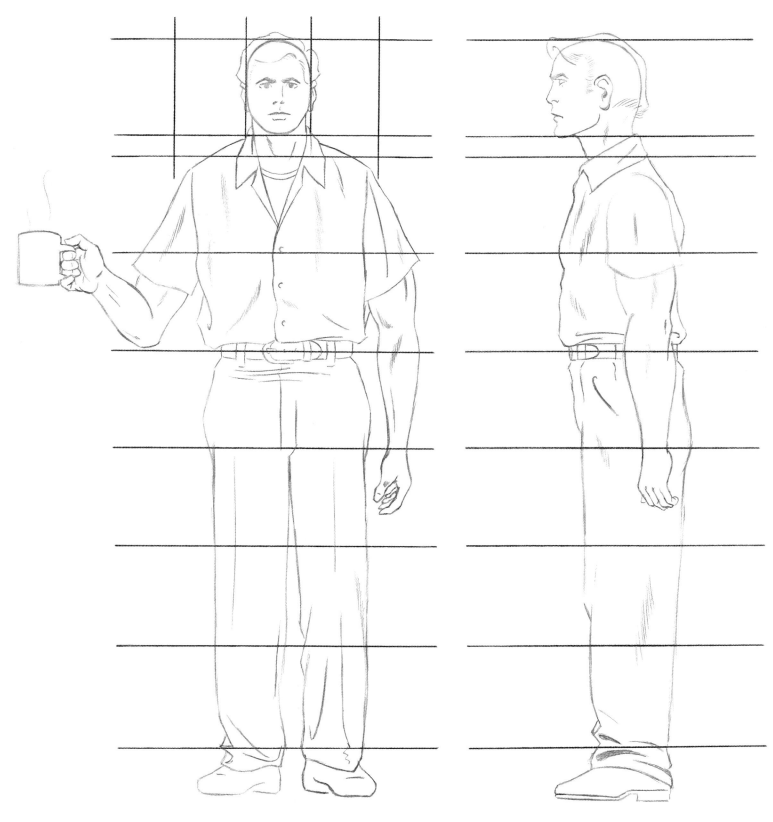

An average male figure is seven heads tall. Notice that the shoulders are three heads wide, the hands fall in the middle of the thighs and the elbows rest just above the waist.

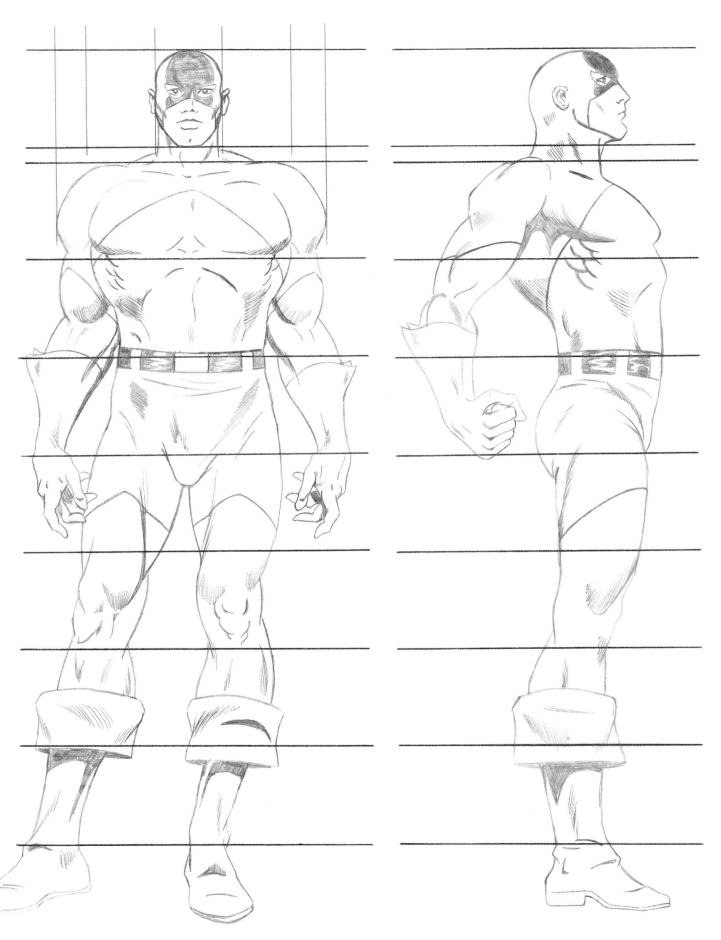

A superhero is eight heads tall. The neck and feet are, generally, not included in the measurement of the figure.

FEMALE FIGURE PROPORTIONS

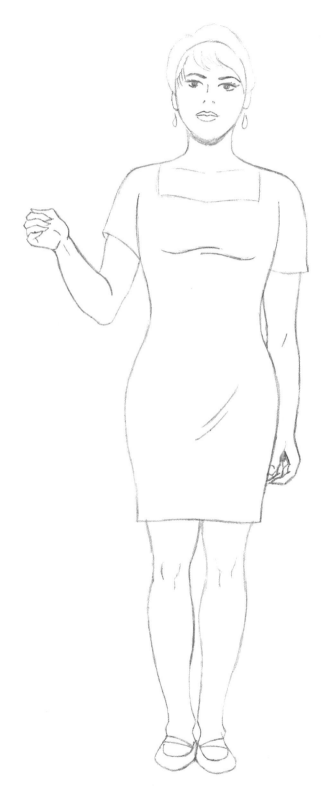
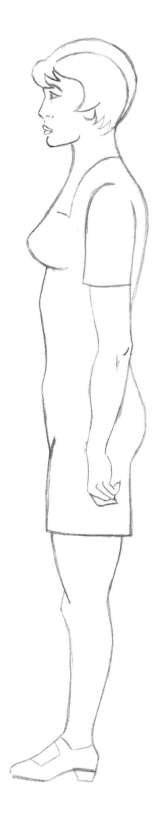

Drawing women follows the same rules as drawing men, but their heads are slightly smaller.

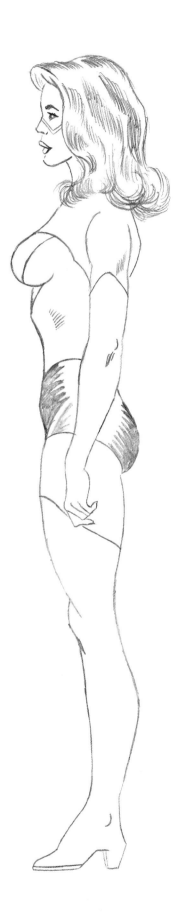
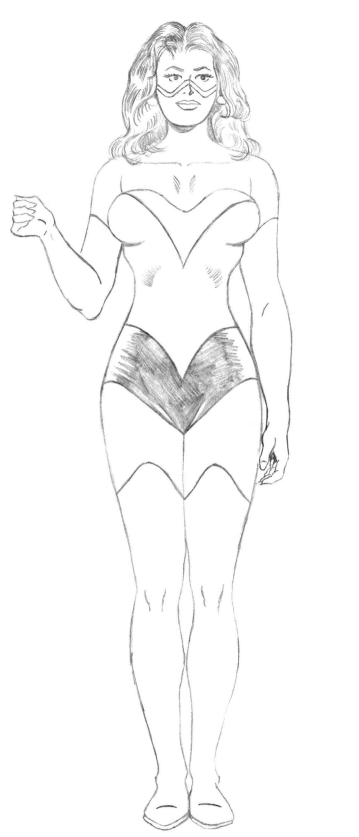

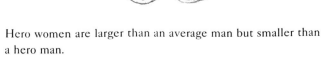

Hero women are larger than an average man but smaller than a hero man.

ANATOMY BREAK-DOWN

Now that we know the mathematics of human proportions, we must lay them out so the figure will look correct when completed. Stick figures that are drawn to create the correct proportions of the characters are called breakdowns, which is exactly what you are doing. You are breaking down the figure into its simplest forms: circles and squares. Breakdowns are always done quickly and sketchily.

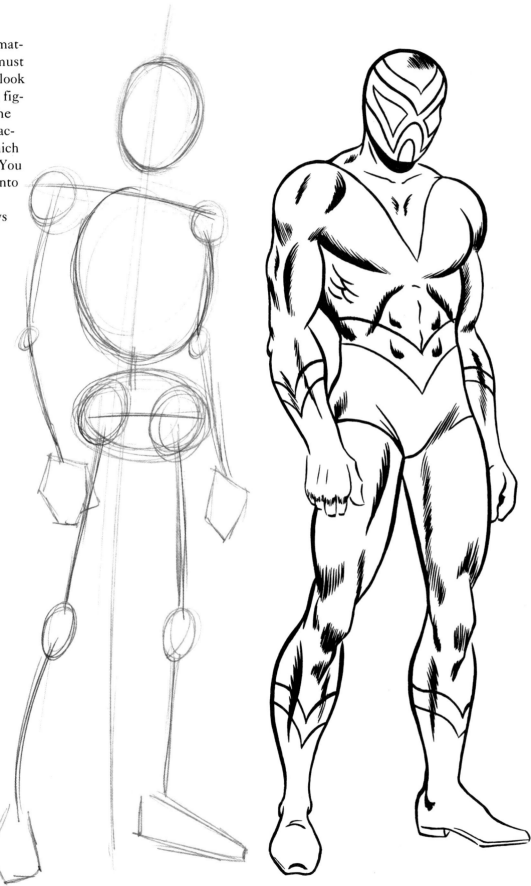

ACTION LINE

You will also notice a long line drawn through this and every breakdown to follow. This is called the action line, which shows you the flow of the body. The action line is the first thing you put down on the paper for each figure you draw. If a man is bending forward, the action line looks like an upside-down *L*. If a girl is reaching for something high on a shelf, the action line is a long, curved swoop from her hand to her feet. However,

it's not often you will draw figures in such stagnant positions as these, so we must make them do something.

The following pages show a multitude of positions and actions that figures can perform, but they're in breakdown form. Breakdown drawing will give you great experience in getting a good sense of proportion, movement and, most importantly, making your characters look natural.

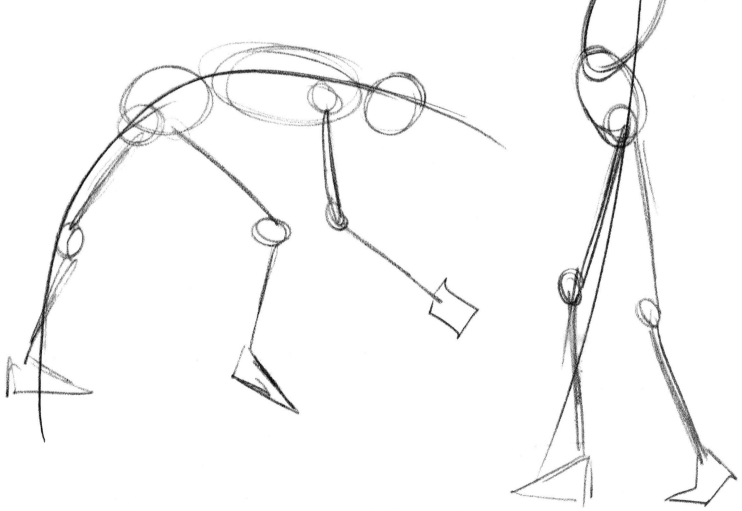

Drawing a simple breakdown or stick figure is how you determine if the proportions of your figure are correct before you draw the entire figure.

ACTION LINE FIGURES

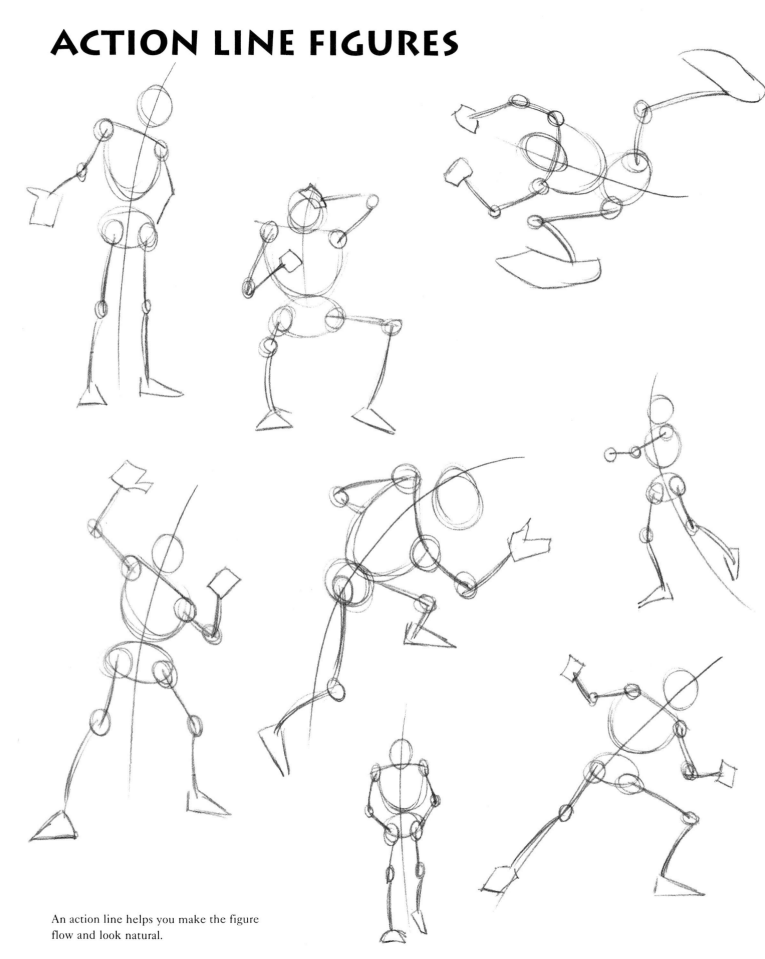

An action line helps you make the figure
flow and look natural.

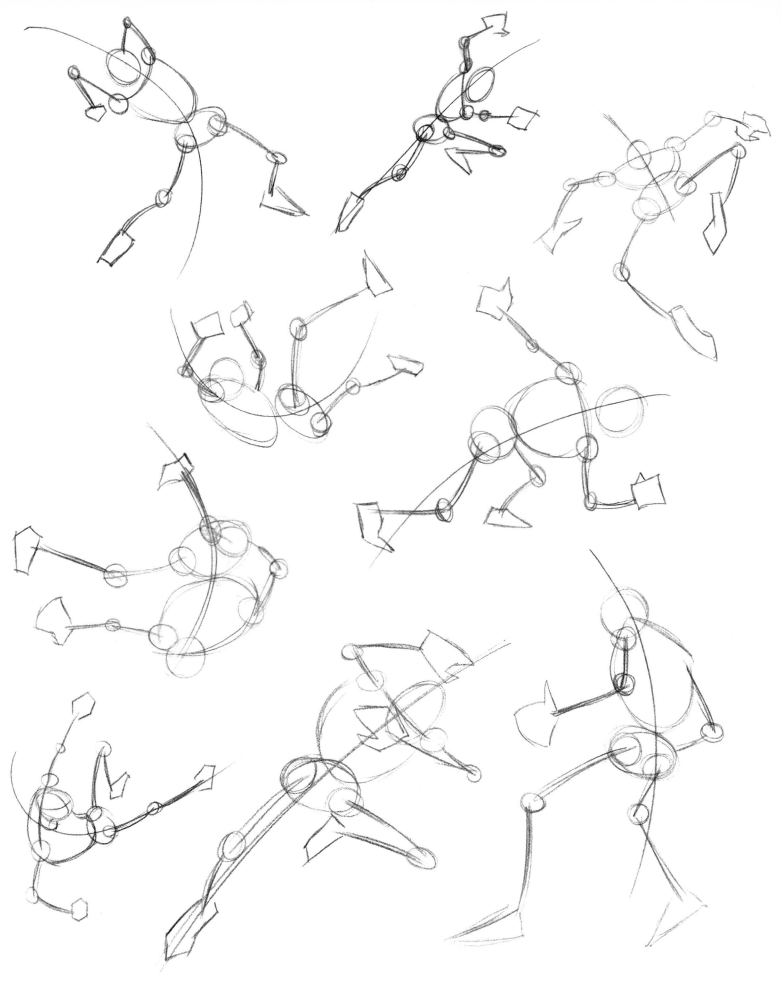

Exercise:
DRAWING BREAKDOWNS

After you have examined the breakdowns I have drawn, make some of your own. Have your figures do anything you can think of: swim, run, put the dishes away—anything. Grab a few friends and ask them to pose for you. Only take a few minutes for each breakdown and jump onto the next one. Keep drawing the breakdowns until you feel you have a good grasp of them. Spend a week, month or more on them. Spend as much time as it takes to learn them well. This is the foundation of your anatomy drawings, so practice hard.

ADDING TO THE BREAKDOWNS

After you feel you have a good sense of breakdowns, you are now ready to add flesh and muscle to the figures.

Take a quick look back at the figures of Captain Atomic (page 23) and Wonderous Woman (page 25). Notice that they are larger than the neighboring average man and woman. As I mentioned earlier, drawings of superheroes are more exaggerated than of normal people. Exaggeration makes your super-hero figures appear more powerful and majestic and keeps your average, everyday figures looking—well—average.

Draw both types of figures many times over. Copy from many different sources. Buy a few muscle magazines and swimsuit magazines and copy the photographed bodies. Study some comics and copy the way other artists draw muscles. Stay away from drawing loose or baggy clothing for now; you're just interested in anatomy. You will draw clothes later. Any kind of practice you can think of will help.

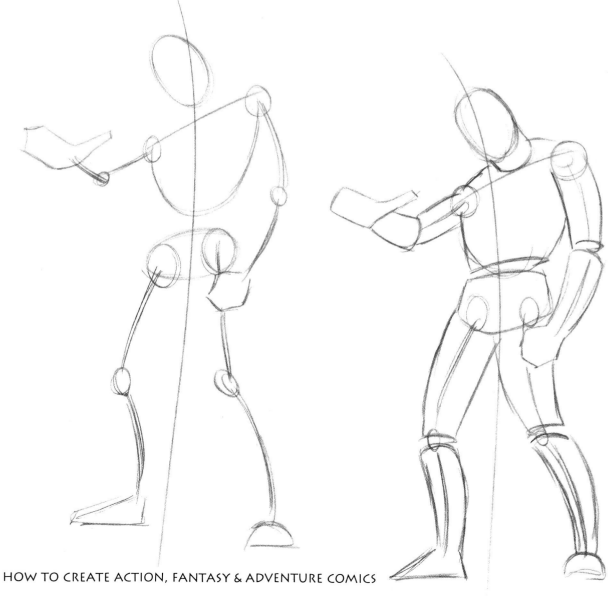

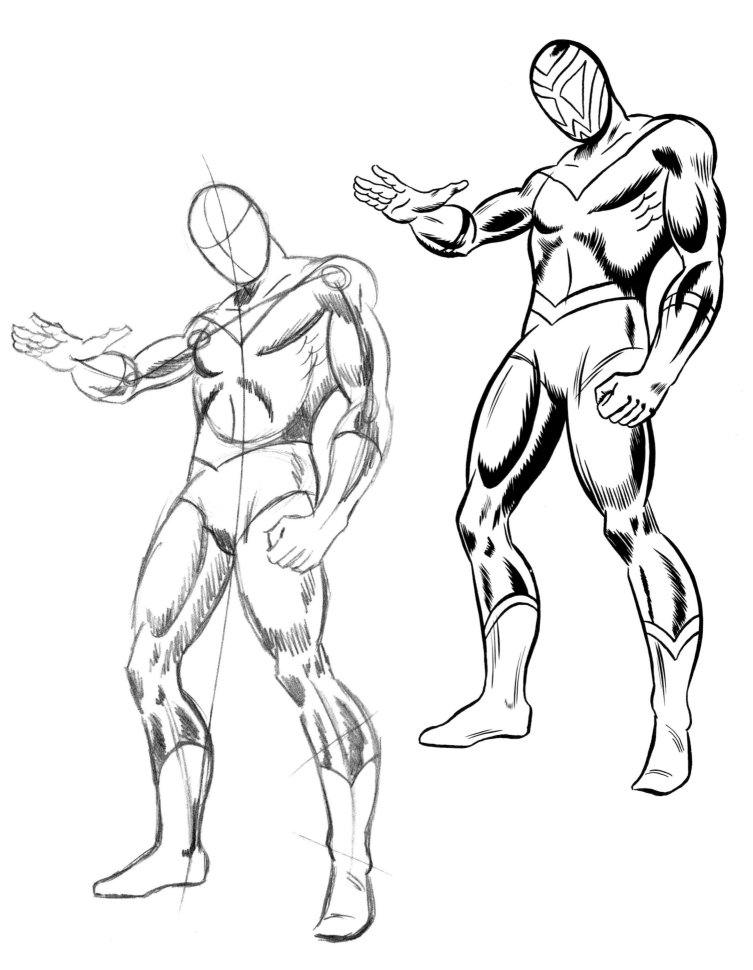

Exercise:
DRAWING ACTION

Let's put a little action in our figures now. The muscles on a body will change as they contract and relax. An arm has more muscle definition when it is lifting something heavy than when it is putting down a cup of coffee. The same rule applies to the entire body.

Examine the workings of your own muscles and those of other people. Although the superheroes appear to have more muscle than the average person, they are still the same muscles, just more developed. It is just as important to study the muscles of Superman as it is to study those of Jimmy Olsen.

When you have gained a good amount of experience with the figure, both normal and heroic, change things a bit. Draw a short, fat man and a tall, thin woman.

Any kind of figure can be drawn once you understand proportions and muscle. This is another reason practice is so important to your art. Try it!

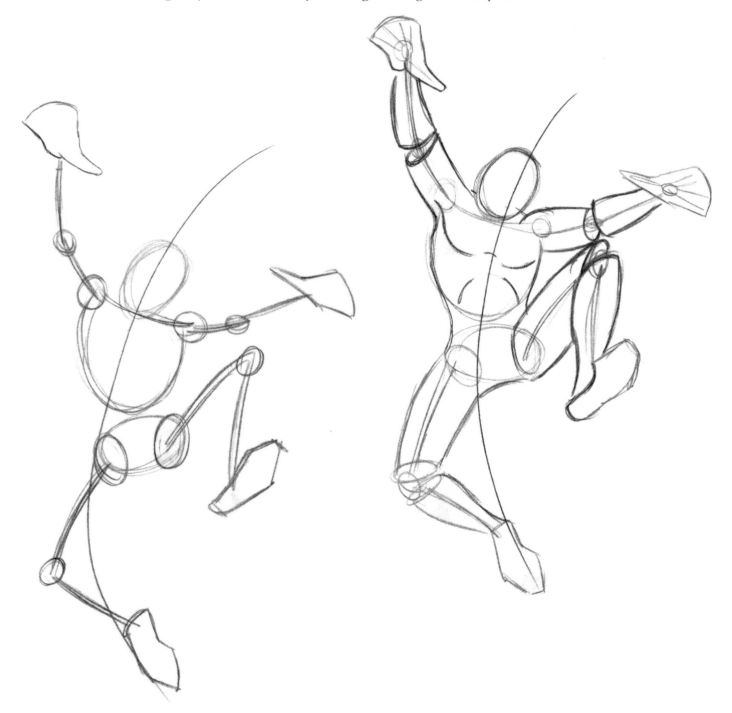

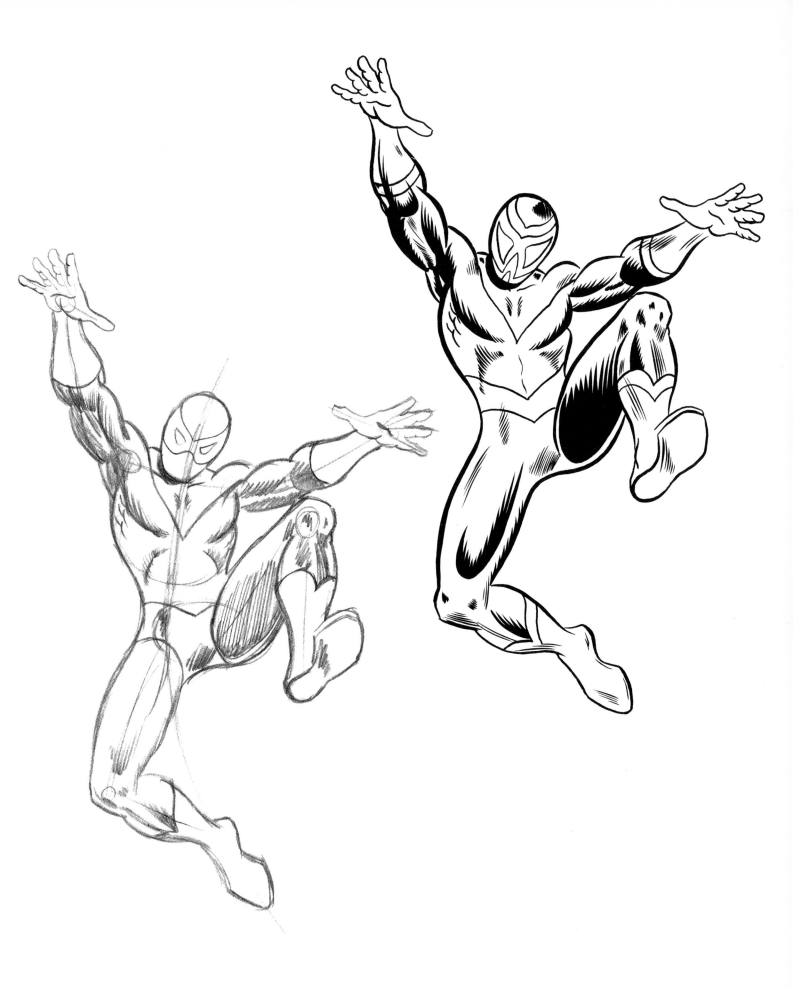

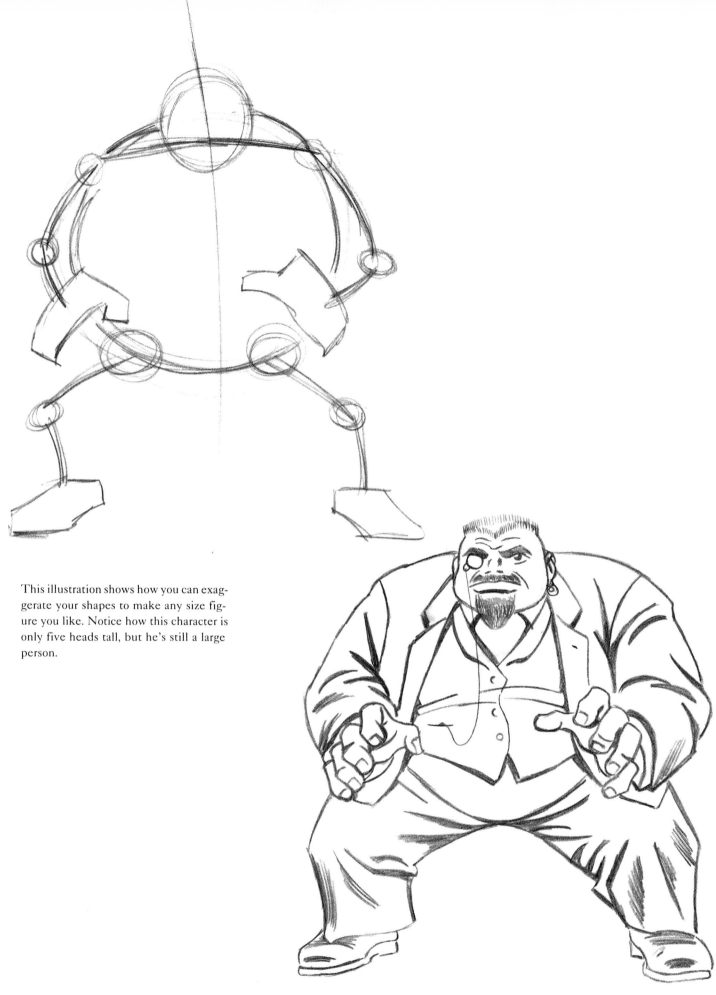

This illustration shows how you can exaggerate your shapes to make any size figure you like. Notice how this character is only five heads tall, but he's still a large person.

The female figure should look smooth, delicate and graceful.

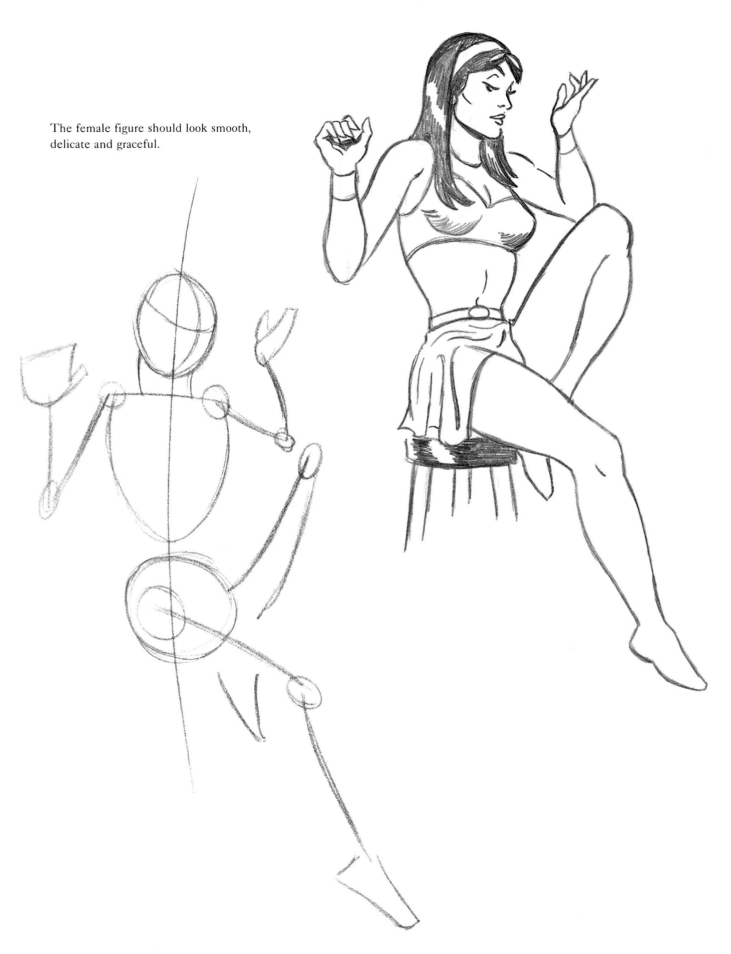

KEEP IN MIND

• The exercises in this chapter are just the beginning of your practical study of anatomy. Simply because I suggest you draw a certain number of figures doesn't mean you can stop there. It takes months and even years of practice to be the best. You must draw every day if you want to have the quality of your artwork continue to grow.

• Don't slack on drawing "average" people. It may not be as exciting as drawing the heroes, but you will have to draw many "regular" people during your career in comics. Just remember to constantly draw the figure because this is what will make or break your art.

• There is an enormous number of good books on anatomy available. Take a look at some of them. Work from them. Learn all that you can from them to add to the knowledge you gain from this book. But remember that you must continue to practice every day.

Exercise:
NATURAL LIFE BREAKDOWNS

On your bond paper pad, create breakdowns for about fifty figures you see doing different things in a crowded area like a shopping mall or a park. Don't take any more than thirty seconds on each one. Try to capture as many different positions as you can. Walk around and look for people doing activities that are out of the ordinary, and draw breakdowns of them.

Exercise:
COPY GOOD ART

Grab a few comic books or adventure comic strips and copy the figures you like from the panels. Draw action lines, breakdowns and complete figures. Choose superheroes or figures that have either tight or very little clothing on. Stay away from drawing clothes for now. Work on as many figures as you feel comfortable drawing in one sitting, ideally about fifty figures.

Exercise:
COPY SCULPTURES

Visit a museum and draw from twenty different sculptures of human figures. If you don't have a museum nearby or you just don't have the opportunity to view large sculptures, try drawing from figurines. Some smaller sculptures are created very well. Make sure the sculptures you draw from are good quality, meaning that they depict the anatomy properly so you can learn by drawing from them.

JOHN ROMITA TALKS ABOUT ANATOMY

• "Don't get sidetracked and bogged down in too much 'technical' anatomy," advises John Romita, who is noted for his work on "Spider-Man." "Try and restrict yourself in the way the surface of the figure looks.

• "Most young artists get wrapped up in all the muscles and the bone structure of the human figure. All you really have to know, as an artist, is the parts that affect the surface and the parts that affect the tension and the dynamics of the figure, that is, how the push and pull of the muscles look with skin wrapped around them and, of course, how light affects them. Too many people get carried away with all the secondary muscles and bone structure way below the surface, and that has a negative effect on how the figure is drawn. Simply put, you have to stick with what af-

fects the surface of the figure.

• "One of the best ways to help yourself learn anatomy and the way the surface of the figure looks is by studying good sculpture in conjunction with your studies of drawing anatomy.

• "Years ago, Michelangelo dissected bodies to see how the muscles lay inside the body and how they affect the surface. Artists today don't have to go through that because of all the references that are available to them.

• "Remember, you are not studying medicine, you are studying art. If you look at the muscles of the face, you'll go nuts. You'll start making horizontal pulls and vertical pulls and circular pulls around the eyes. You'll end up with a million lines, and everyone will look like a mummy."

HEADS, HANDS AND VISUAL EXPRESSION

Visual expressions can be more important than words. Heads and hands, the lifeblood of comics and their source of visual expression, deserve special detail. That's why I have dedicated an entire chapter to studying them. Hands and faces tell a lot about what characters are thinking. Because of this, it's important to show a character's hands as often as possible, even if the main image is a facial close-up.

HEADS

Ever since you were old enough to pick up a pencil, you have drawn a head of some sort. Now you will learn the details of how a head is truly constructed. To begin with, you must realize that the head is mathematically accurate. Everything is in a special place in relation to everything else.

The head starts out as an egg-shaped oval that is divided in half both horizontally and vertically. The horizontal line locates the eyes, while the vertical line places the nose. These two crossing lines also give you the foundation of everything else on the head and help you determine which way the head is looking. Simply by curving each of these lines in different ways, you can have the head look anywhere you want. With only these two simple lines, you can decide if you like the position and angle of the head you will be drawing, even though you haven't drawn it yet.

STRAIGHT-ON VIEW

After you have drawn your oval or egg shape, divide it in half vertically and horizontally. As I said earlier, these two lines determine the location of the eyes and the nose. Note how a horizontal line drawn connecting the two eyes divides the head exactly in half. This may not sound correct, because hair gives the illusion of eyes being closer to the top of the head than they really are. But this is simply an illusion. You will see how this works later.

PLACING EYES AND EARS

Let's work on the head, starting with the eyes. The eyes are a form of measurement. The head is exactly five eyes wide. This can be determined by measuring from one side of the head to the first eye, the eye itself, the distance between the two eyes, the second eye and the distance from the second eye to the opposite side of the head.

The eye line also indicates the starting point of the ear, that is, where the ear begins to grow out of the head.

PLACING THE NOSE, MOUTH AND EARLOBES

Now look at the bottom half of the face. Draw a horizontal line dividing the bottom of the face in half. This locates the base of the nose. The tip of the nose is slightly higher than the base.

Divide the distance between the base of the nose and the chin in half to place the bottom lip. The upper lip is drawn slightly higher than the bottom lip.

Draw the earlobes just below the guideline used for the base of the nose.

FINISHING THE NOSE AND MOUTH

Let's get vertical for a moment. Draw guidelines vertically from the inner edge of the eyes down to the nose to position the outer edges of the nostrils. Extend a similar guide from the center of the eyes down to the mouth to see where the ends of the lips fall.

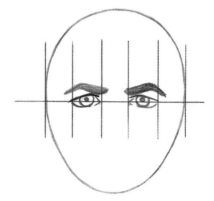

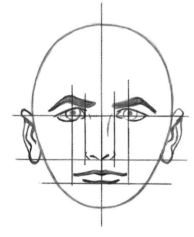

Notice that the head is exactly five eyes wide. Guides help you to keep all the features of the face in their proper places.

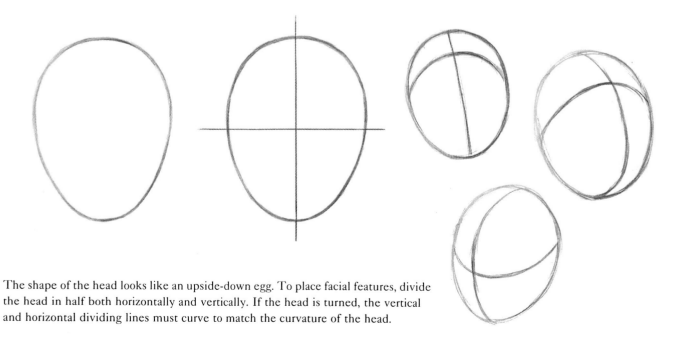

The shape of the head looks like an upside-down egg. To place facial features, divide the head in half both horizontally and vertically. If the head is turned, the vertical and horizontal dividing lines must curve to match the curvature of the head.

SCULPTING THE FACE

Now that you have most of the features in place, begin to sculpt the face. For the man's face, draw strong but not harsh angles for the jaw and chin to create the stereotypical square chin and portray the illusion of strength and power within your character.

The top half of the head is mostly taken up by hair, the style of which is totally up to you. What you must remember is that the hair has body to it. Hair will never rest directly on top of the head. Give it some fullness and bounce, and your characters will look more natural.

Remember to show that the hair has body to it and doesn't rest flat on the top of the head.

Exercise:
TURNING THE HEAD

What about turning the head? You know that the head is a lot wider from front to back than an egg shape, so you need to draw it that way. When the head begins to turn toward the figure's left (your right), you must show that the back of the head protrudes outward. Mass has to be proportionately added to the back of the head as it turns all the way to a complete profile.

Start with the egg shape and divide it in half both vertically and horizontally with straight lines. Sketch in a solid curved vertical line to show the direction the head is looking. Measure the distance between the dashed vertical line dividing the oval in half and the solid curved vertical line. This is the amount of extra mass you need to add to the back of the head. Once this is completed, simply add all the other components of the head in the correct locations.

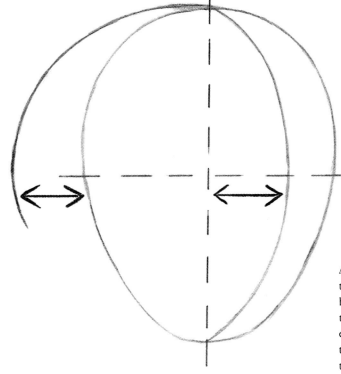

As the head turns, the portion of the back of the head that is seen is equal to the distance the head has turned.

KEEP IN MIND

• All the guides and examples we have covered in this chapter work no matter what position the head is in. Just remember to curve your guidelines to the proper angles of the head. These rules apply to drawing women's heads as well. The only difference is that you make the degree of softness in a woman's head as great as you did the strength in a man's head. Men's heads are angular and sharp, while women's are more curved and genteel.

• No matter what gender you are drawing, always keep the faces clean. Unnecessary lines will only make the characters look old and worn out. There will be times, however, that you want this look, but for now, let's keep the characters fresh.

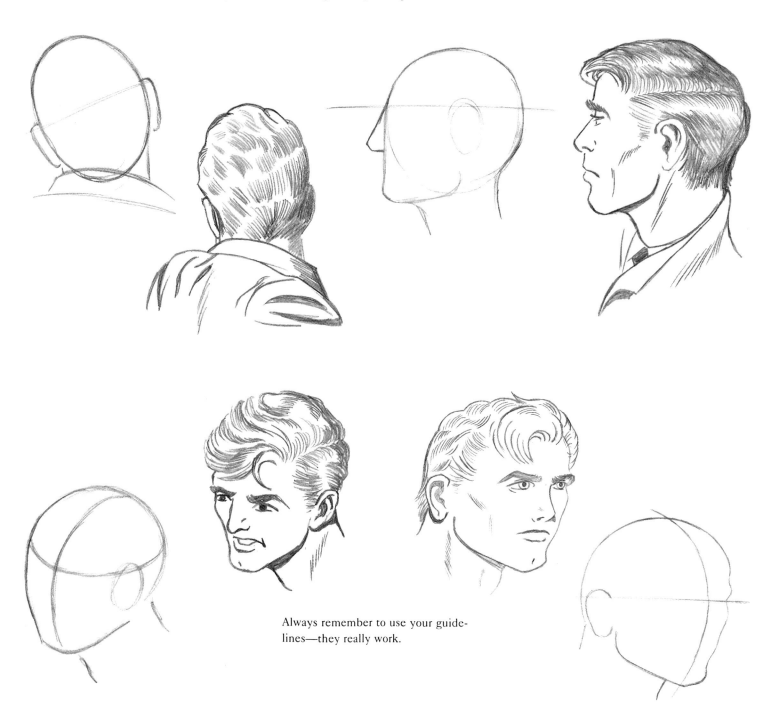

Always remember to use your guidelines—they really work.

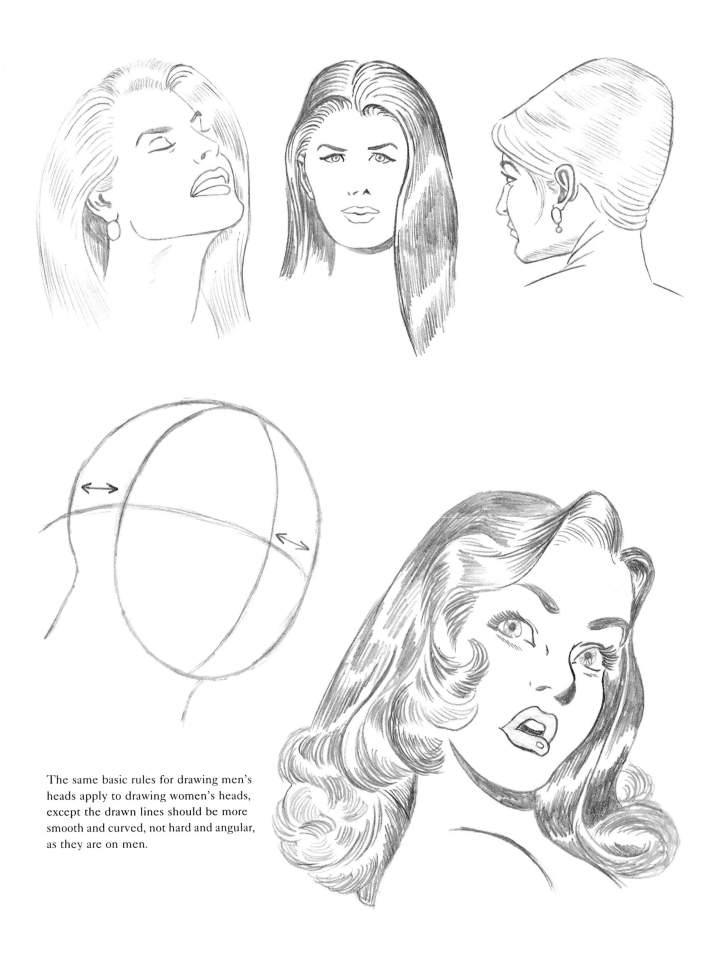

The same basic rules for drawing men's heads apply to drawing women's heads, except the drawn lines should be more smooth and curved, not hard and angular, as they are on men.

FACIAL FEATURES

Now that you have a good understanding of how the head is constructed, let's get into the detail and learn about the individual features of the face. The eyes of your characters give more expression than any other feature of the face, so it is important to draw them well. Note how the upper eyelid covers the top of the iris (colored part of the eye), while the iris appears to rest on the lower lid. Don't forget to include the tear duct in the corner of the eye. On men, draw the eyelashes and eyebrows as solid black shapes. On women, you may draw individual eyelashes, but don't overwork the hairs. Women's eyebrows are also solid shapes. When drawing a close-up, keep in mind that eyebrow hairs grow from the bridge of the nose toward the outer edges of the eyes.

The nose doesn't change much with different facial expressions; however, the nose isn't anatomically simple. To give a youthful look or feel to your characters, keep a slight upward tilt to the base of the nose. Never completely draw in the full outer edge of the nostrils. All you need is a simple line as a hint of the nostril and to denote where the light is coming from, which is usually above the character's head.

The mouth is drawn smoothly and shapely. Keep away from sharp angles that will make a mouth look as if the face was carved out of wood. The upper lip protrudes outward slightly farther than the bottom lip when drawing a profile. A man's mouth simply shows the shadow of the upper and lower lips. Don't draw the entire lip of the man as you would for the woman.

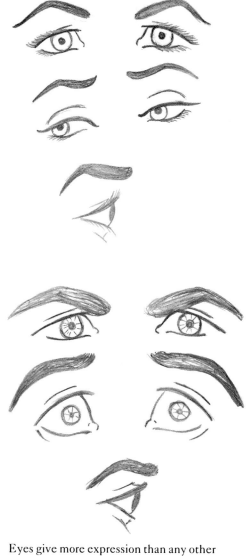

Eyes give more expression than any other feature of the face.

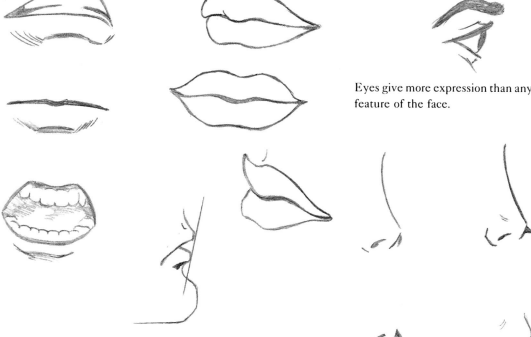

Men's lips are never drawn in completely, but women's are.

Keep noses small and simple.

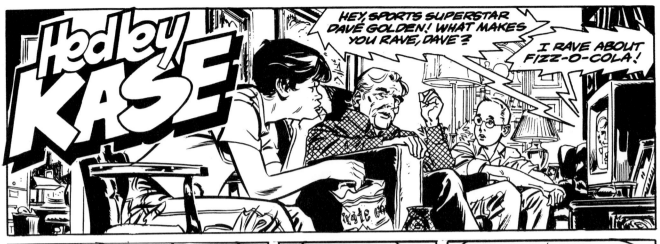

Hedley KASE

HEY, SPORTS SUPERSTAR DAVE GOLDEN! WHAT MAKES YOU RAVE, DAVE?

I RAVE ABOUT FIZZ-O-COLA!

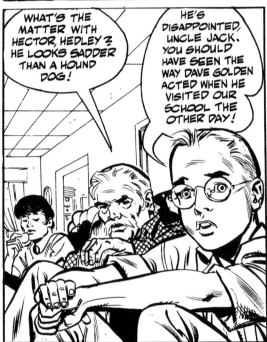

WHAT'S THE MATTER WITH HECTOR, HEDLEY? HE LOOKS SADDER THAN A HOUND DOG!

HE'S DISAPPOINTED, UNCLE JACK. YOU SHOULD HAVE SEEN THE WAY DAVE GOLDEN ACTED WHEN HE VISITED OUR SCHOOL THE OTHER DAY!

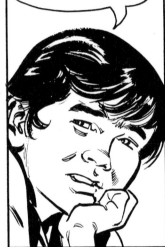

MAN, I CAN'T BELIEVE IT! DAVE GOLDEN HAS ALWAYS BEEN MY IDOL! THEN I SEE HIM UP CLOSE, AND HE TURNS OUT TO BE A TOTAL JERK!

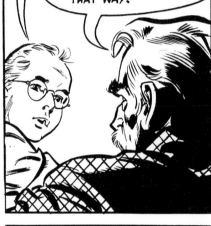

DAVE WOULDN'T SIGN AUTOGRAPHS! HE WOULDN'T TALK TO TARA WHEN SHE WANTED TO INTERVIEW HIM! HE REALLY ACTED STUCK UP!

WELL, HE'S NOT THE FIRST SUPERSTAR ATHLETE WHO HAS ACTED THAT WAY!

SURE, BUT THAT DOESN'T MEAN HE SHOULD ACT THAT WAY! YOU WERE A FAMOUS ATHLETE, MR. CACTUS. I'M SURE YOU WEREN'T LIKE THAT!

THANKS, HECTOR, BUT I'M SURE I HAD MY MOMENTS. BESIDES, I WAS NEVER AS FAMOUS AS DAVE GOLDEN!

IN MY DAY, SPORTS WEREN'T ON TV AS MUCH AS THEY ARE NOW! REPORTERS DIDN'T WRITE ABOUT EVERY LITTLE THING YOU DID. I'LL BET IF DAVE GOLDEN BURPS IN PUBLIC, A STORY ABOUT IT WILL BE IN THE NEWSPAPER THE NEXT DAY!

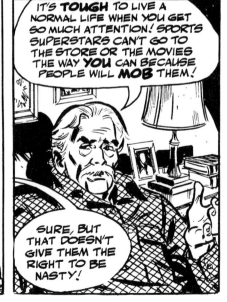

IT'S TOUGH TO LIVE A NORMAL LIFE WHEN YOU GET SO MUCH ATTENTION! SPORTS SUPERSTARS CAN'T GO TO THE STORE OR THE MOVIES THE WAY YOU CAN BECAUSE PEOPLE WILL MOB THEM!

SURE, BUT THAT DOESN'T GIVE THEM THE RIGHT TO BE NASTY!

Examine how Frank Springer deals with heads and all their features.

HEDLEY KASE © FRANK SPRINGER.

DRAWING THE HAND

Artists commonly believe that the human hand is the most difficult thing to draw—and I totally agree. The hand takes much practice (as does everything) just to look correct.

There are no set measurement rules for the hand as there are for the head. For the hand, it is best to break it down into cubes and cylinders to get the basic shape (as we have seen in the human body) and then tighten up the hand to its proper form.

The only rule for drawing hands is to be attentive—and to practice. Use live models when possible, since this way you'll see the true folds of the skin and shape of the fingers.

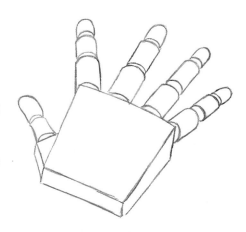

Like the human body, the hand can be broken down into simple shapes.

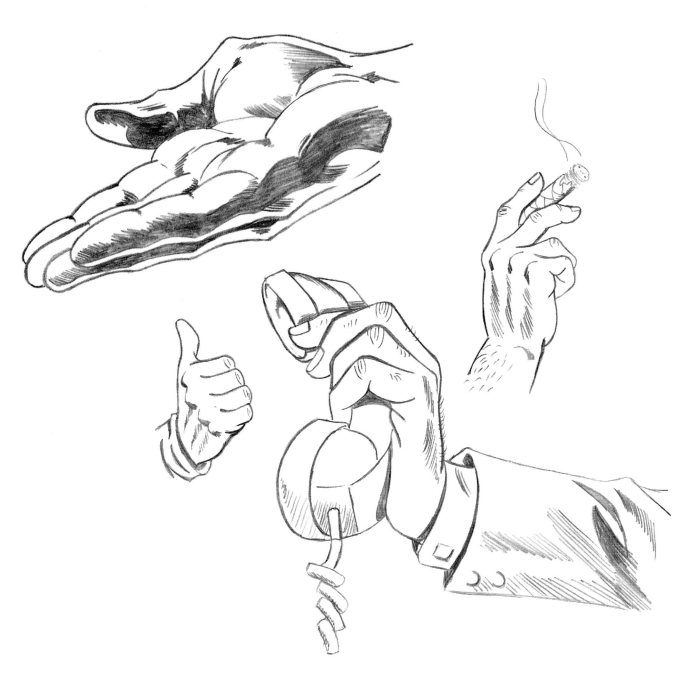

MICHAEL MORGA TALKS ABOUT HEADS AND HANDS

• "Proper proportion is everything when creating character heads and hands," says comic illustrator Michael Morga. "What makes the likeness of a character is the right proportions. Nothing else will do the job. No matter how large or small your drawings or how detailed your work, nothing substitutes for lack of good proportions. The only thing that is going to make the person you are drawing look like the person you want it to look like is proper proportions. This is most important in comics, especially if you are working with one character that you must draw over and over again in all different views.

• "The same rules of proportion apply when drawing the entire figure. If you have the wrong proportions for a superhero, he or she won't look like a superhero. Whatever part of the human figure you are drawing, you must have the proportions correct, or your drawings will be very unpleasant to look at.

• "Another important aspect of drawing heads and hands is line quality. Knowing where to place darker lines as opposed to lighter lines is imperative when drawing heads and hands. Hard angles and turns, like around the edge of the nose in a three-quarter view, should be drawn with extremely dark lines. Straight runs, such as the con-

tour or outer edge of the face, should be a lighter line. Varying line qualities give the feeling of depth and reality to your characters. They also put more personality and life in the faces and hands of your drawings.

• "An expression on a face and a gesture with a hand can tell more of a story than three pages of text. Never, ever hide the hands. They are very expressive and need to be utilized to the fullest. Help tell the story with your character's hands. Even if it's a simple dialogue between two people in an office, the hands can really express the character's mood to the audience."

KEEP IN MIND

• Study your own and other people's expressions. Try to capture feelings through visual expressions in your drawings. A few simple adjustments to the features on the face can show completely different feelings in your characters.

• The trick to creating successful comics is keeping the faces of particular characters looking the same each time you draw them.

• Carefully examine how other cartoonists draw heads and hands, and compare your work to theirs.

Exercise:
SELF-PORTRAIT

Prop a mirror up by your drawing area, and draw your own face in every different expression you can.

Exercise:
DRAWING OTHERS

Using any mail-order catalogs that are lying around, draw all the faces you see. Once you find a face you really like, begin to draw that face in different positions and expressions. Try to keep the likeness of the face in each drawing. You will find it challenging to draw a face in many different positions and expressions when you can only view it from one angle in a photo.

Exercise:
DRAWING HANDS

Copy as many hands as you can from your catalogs. When possible, copy live models' hands.

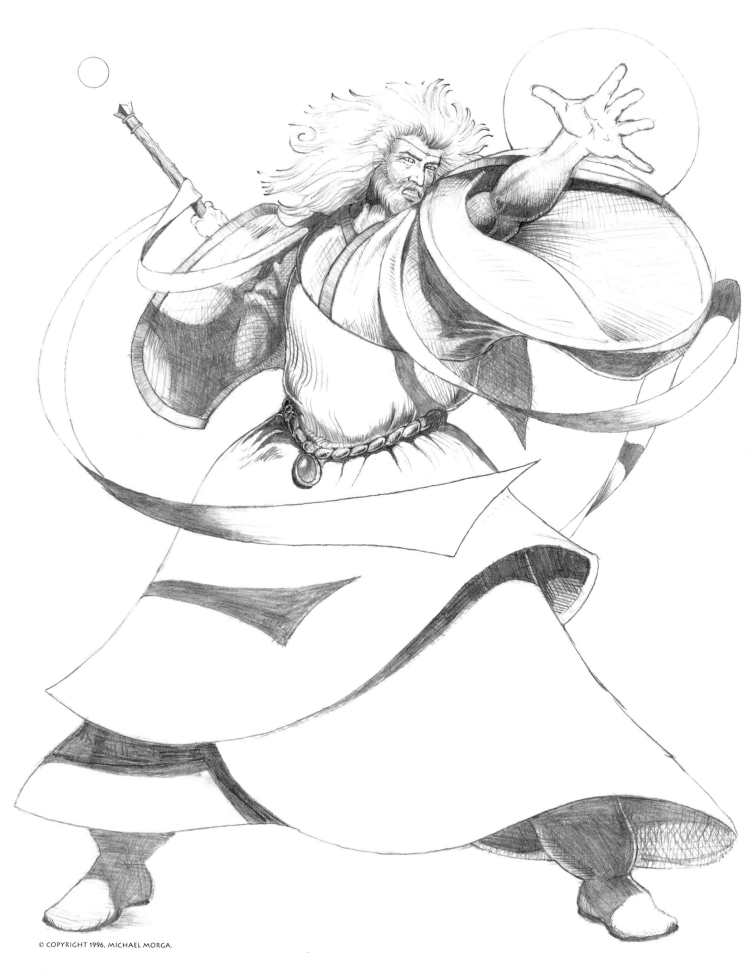

CLOTHING AND DRAPERY

Now that you have a good under-standing of human anatomy, it's time to clothe the figures you draw.

Since superheroes are only about one-quarter of all the figures in comics, you can see the necessity of being able to draw clothing and drapery. It's easy to place a giant *S* on the chest of a figure, slap some color over that figure and say it's a superhero, but what happens when that hero is in his secret identity? He certainly doesn't wear a skin-tight, three-piece suit. Besides, you might work on a strip or book that has *no* superheroes in it at all. "Mary Worth," "Apartment 3G," "Brenda Starr," "Prince Valiant" and many others have absolutely no superheroes in tight-fitting cos-tumes.

Before you begin to draw, collect a bunch of catalogs—Sears, J.C. Penney, Lerner and, hey, even the Victoria's Secret catalog—and keep them close at hand as you read this chapter, and quite possibly for the rest of your career. You will refer to them continuously throughout the remainder of this book.

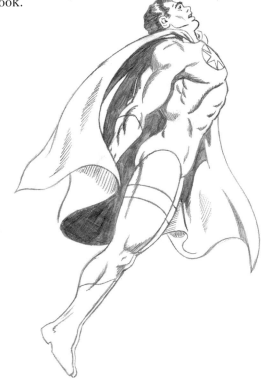

BASIC FOLDS

There are four basic types of clothing folds: gravity, extension, joint and compressed. Each of these share the same basic element: the fold origin point. The folds may sound quite confusing at first, but they are relatively simple to draw.

The fold origin point is the starting point for the folds. In most cases, it occurs at the armpit, elbow, knee, crotch, neck, shoulders or waist. In other situations, the fold origin points occur at clothing seams and fabric areas that are tight against the body.

GRAVITY FOLDS

Gravity folds are the easiest kind to draw and are a good starting point for learning clothing folds.

In the illustration on the right, a man leans against an object, at rest. Because he's not making any gestures that would create folds on his shirt, gravity alone creates the folds. See how fold origin points occur at the shoulders and the collar of the T-shirt. The folds begin flat on the shoulders where the shirt is tight against the skin and grow in thickness as they are pulled down by gravity.

Because the man's body is slightly twisted to his left, the folds don't fall straight down but curve toward his right. The twisting causes a large fold to begin at the top of his left shoulder and drop diagonally across his chest. The degree of twisting determines the amount of bend in the folds. The general rule is if a figure twists to the left, the fold origin point begins at the left shoulder and curves down to the right, and if the twist is to the right, the opposite is true. The collar creates a small fold because it is slightly compressed against the shoulder.

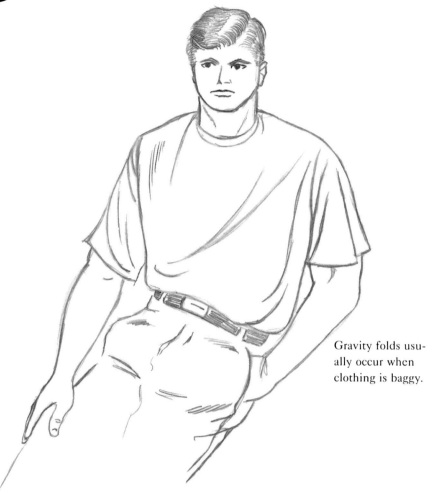

Gravity folds usually occur when clothing is baggy.

The only time a shirt's folds fall straight down is when there is absolutely no twisting and the shirt is loose and baggy. The shirt can't be tucked into the pants or resting on the figure's lap, which affects the natural flow of the folds. An example of directly vertical gravity folds is in the man's left sleeve. The right sleeve has a slight twist to it, and that curves the folds.

Tight-fitting clothes will never create a gravity fold effect.

The woman (page 53) is wearing a full-length dress. Since she is also at rest, all we see on her dress are gravity folds. As you can see in the drawing, these folds also drop from the shoulders, but since the woman's upper body is straight, the folds drop straight down. You also see that there is a seam around her waist that causes many more folds to form at the top of the skirt than if there were no seam. These folds fall straight to the bottom of the dress where they cause the hem to weave in and out. In effect, the folds overlap one another and create the illusion of three dimensions in the drawing.

This superhero (page 53) illustrates the use of gravity folds in comics. As this caped hero stands in one of his majestic poses, you can see the gravity folds on his cape. Notice that the cape flows straight down as did the female's dress. A similar overlapping effect occurs at the bottom of both the dress and the cape. The two "Mary Worth" examples (page 54) show everyday people with gravity folds on their clothing.

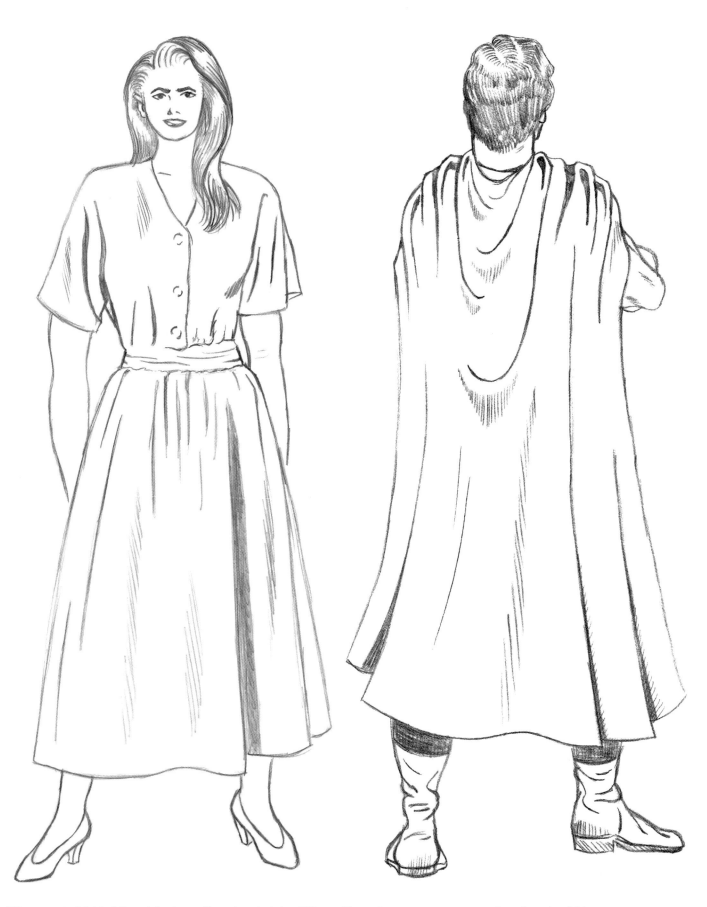

Direct vertical folds fall straight down. Keep in mind the differences in men's and women's anatomies, which affect folds differently.

Heroes' capes are great examples of gravity folds.

KEEP IN MIND

• The differences in male and female anatomy affect folds. Folds fall differently on a female's chest than on a male's chest. The clothing on a female's chest tends to be tight against the breasts causing new fold origin points. These new fold origin points utilize the same rules about gravity affecting clothing as discussed above, but they produce shorter folds.

Exercise:
DRAWING GRAVITY FOLDS

Examine some comic strips and comic books and see how many examples of gravity folds you can find. Now, go through one of your catalogs and find a few pictures of clothes with gravity folds. Place a sheet of tracing paper over the photo, and trace the figure and the folds. This doesn't have to be perfect, just get a feeling of how the folds work. It's the best way to practice drawing folds.

Drapery doesn't always refer to curtains. The man, on the left has a sheet tucked around his body.

Tracing folds from other comics and photographs is a good way to practice, but don't get hung up on tracing.

EXTENSION FOLDS

Extension folds result when an arm or leg pulls against a fold origin point. This is a great way of putting action into action comics. You can really show power with the proper use of extension folds.

To draw an extension fold, first determine the origin point. The folds then radiate out from that point. To figure out the origin point for extension folds, ask yourself, What area is being pulled? In extension folds, most of the origin points are seams in clothing. Because an area of clothing is being pulled, that doesn't mean that the fold origin points have to start at clothing that is tight against the skin, the way it does in gravity folds.

Take a look at the man below who is pointing. His suit jacket is, typically, not tight to the body. Since he is pointing, his raised arm causes folds to occur. The folds begin at the armpit where the seam creates the most tension against both the sleeve and the jacket.

Next, decide where the folds extend to by determining what is pulling against the fold origin point. In this case, there are two answers: the outer edge of the arm where the sleeve is tight against the entire length of the arm, and the jacket button. Notice that all of the folds begin at the fold origin point, but they do not all converge together the same way. Folds radiate out to different end points. Even though the button of the jacket is one of the end points, all the folds do not meet there. The button and the sleeve only *cause* the pull against the fold origin point (the armpit), indicating the general direction the folds spread to.

The jacket button doesn't pull from the fold origin point with as much tension as the arm does, so there are fewer folds. The sleeve pulls with much more tension, so there are more folds. A good point to remember is the tighter the pull, the greater the number of folds and the thinner the folds become.

There are other fold origin points that affect the look of clothing but aren't standard fold origin points. One example is a piece of clothing that is tucked into another or is unnaturally tight, as if bound, against the body. The illustration on the right of a T-shirt tucked into a belt line shows this. The T-shirt now has a new set of fold origin points that work along with the ones discussed above. Because of the upper pull of the T-shirt, the extension folds radiate out from different areas of the belt line when an arm is extended.

This same effect takes place in the lower body as well, shown in the illustration on page 56. As a leg is extended, the fold origin point becomes more obvious. In most cases it occurs at the seam in the crotch. The folds radiate along the

The tighter the pull, the greater the number of folds and the thinner they become.

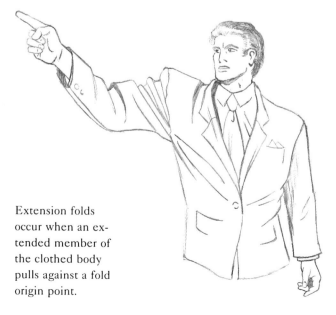

Extension folds occur when an extended member of the clothed body pulls against a fold origin point.

outer edge of the extended leg.

Now for the tricky part of extension folds. When the limbs are extended, the clothing becomes tight against the outer edge of the particular limb being extended, but the clothes do not stretch along with the limb. The extension actually causes the clothing to pull back slightly *toward* the fold origin point and produces overlapping folds on the outer edge of the extended limb. In addition, the shirt sleeve or pant leg becomes shorter at the end so you must show more of the arm or leg.

The figure of the woman reaching for an object (page 57) gives a detailed illustration of how the folds bunch up on the outer edge of the limbs. This is a fold that will become second nature to you. You'll soon know where to place it without even thinking about it, but you must first copy this type of fold many times over from real life or photographs to really get the full feel of drawing it.

Extension folds are created also when a person puts a hand in a pocket, as seen in the "Mary Worth" panel (page 57). The weight of the hand pulls against an area of clothing that is tight against the body. The same drawing rules apply: Find the fold origin point, determine where the folds radiate to, figure out if they are tight and thin folds or loose and few and then draw them in.

The panel of the woman removing her jacket (page 57) is an example of unnatural extension folds. Unnatural extension folds are folds that are created when some force, other than the way the body naturally bends, acts upon the cloth to make folds, such as when clothing snags on something or a person pulls the clothing in an odd way. Examine the folds of the jacket carefully and try to determine where all the fold origin points are.

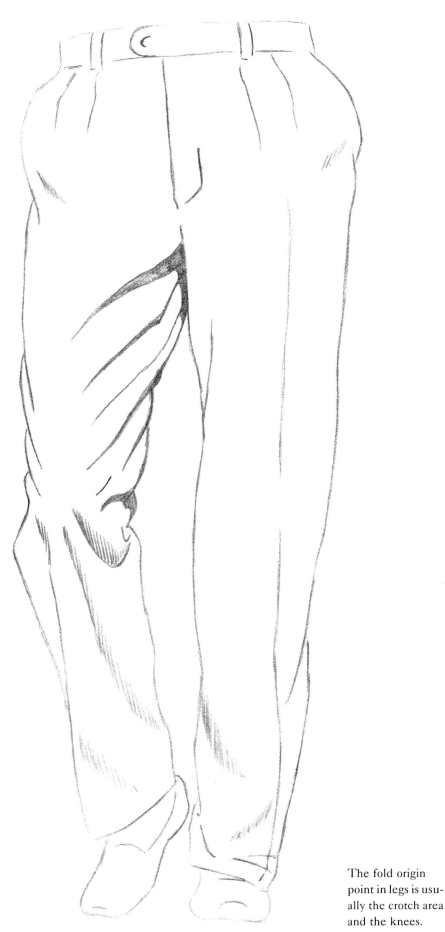

The fold origin point in legs is usually the crotch area and the knees.

Exercise:
DRAWING EXTENSION FOLDS

Now take a break and look at some of your catalogs. Find pictures that have extension folds in them. Lay tracing paper over one, and trace how the folds fall. Don't forget to concentrate on the tight folds that form on the outer edges of the limbs.

When one area of the clothing is tight against the body, there is another area that is loose. Watch for this in your drawings.

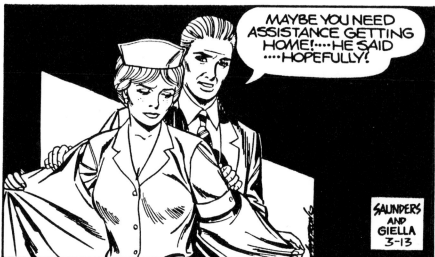

Extension folds don't always need seams. Sometimes they just need something to be pulled on.

REPRINTED WITH SPECIAL PERMISSION OF NORTH AMERICA SYNDICATE.

Extension folds are created whenever something is pulling against a seam of the clothing, such as when people put their hands in their pockets.

REPRINTED WITH SPECIAL PERMISSION OF NORTH AMERICA SYNDICATE.

JOINT FOLDS

Regardless of the clothing material, joint folds happen in the same manner on all figures. Joint folds are seen when you view a clothed and bent joint, such as the elbow, knee or waist. These will probably be the most common folds you will draw. They are visible only from the side and three-quarter views of the bent joints. When a bent joint is viewed from directly in front of the bend, the folds change in appearance and become compressed folds, which are discussed on page 59.

As in the other folds, you must first determine the joint fold's origin point and work from there. In the bent elbow panel (below), you see that the outer edge of the elbow becomes the fold origin point and the folds radiate from there. As we discussed in the other types of folds, the clothing is usually tight at the fold origin point, and it is the same here. You see that the clothing covering the elbow is tight

against the skin and the elbow is evident from within the jacket. Unlike extension folds, the folds don't spread out to multiple end points. In fact, the folds circle around the joint and end at the inner bend of the joint.

Just because joint folds have specific areas they form in does not mean there are no other types of folds that coincide with joint folds. Extension folds are often found in the same general area as the joint folds. This must be determined by you, the artist, as to what type of action is taking place and what type of extension folds to add along with the joint folds. In the panel with the man sitting (page 59), the bent knee has extension folds on either side of the joint folds. Look closely at the example, and see if you can determine the fold origin points and where the pants are tightest and loosest over the body.

Probably the most difficult part

of drawing joint folds is to make the clothing look as though it is overlapping itself on the inside of the joint. This is accomplished by observation and practice. Carefully examine both examples above and all the joint folds you can find in your catalogs and comics. Look not only at the folds but at the outer edges of the clothing, which make or break good joint folds. Also keep in mind that the limbs are rounded and therefore the folds curve around the thickness of the limbs they are covering.

The same events take place when the bent joint is at the waist. The back becomes the fold origin point, and the stomach is where the clothing overlaps itself. You can only see the waist's folds from the side or three-quarter view because the body covers it up when looking at it straight on.

Exercise:
DRAWING JOINT FOLDS

Once again, flip through your catalogs and comics and identify some joint folds. Study large images, if possible, because joint folds can be very small. Lay your tracing paper over the pictures, and trace the folds and the contours of the figures. At this point, you should easily be able to determine the fold origin points.

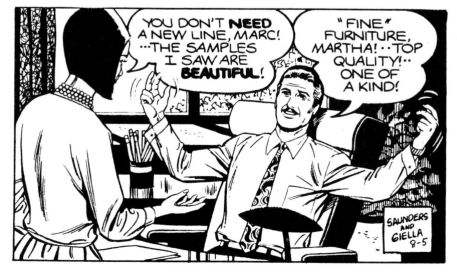

Joint folds are trickiest to draw because you must draw the clothing so it appears to overlap itself on the inside of the joint.

Joint folds occur when any clothed joint of the body, such as this man's knee, is bent.

COMPRESSED FOLDS

The final type of folds are compressed folds, which happen when the clothing on any part of the body (mainly limbs) is bunched together. A good example of this is when a shirt sleeve is pushed up the arm or a sock has fallen down to the base of the ankle. In this type of fold, there are no fold origin points or end points. The folds simply take on their own specific characteristics.

Compressed folds originate on both outer edges of the limb that the clothing is covering. These folds can be easily described as zigzag folds because that is exactly what they do, depending on how tightly compressed the folds are. The folds cross over each other but don't usually reach the opposite side of the limb. The only time compressed folds reach the other side is when the clothing is compressed very tightly. This will cause the folds to simply cross from one side to the other, and the ma-

terial will bunch up on the outer edges. These are very simple to draw, so you should have no problem with them.

Compressed folds consist of main folds with smaller folds alternating between them. Any shiny material shows compressed folds well and looks amazing when drawn properly, but the more common cotton clothing is what you will probably be drawing most often. No matter what the material, the folds fall the same way.

In the illustration of the man standing (page 60), the arm with the jacket sleeve pushed up is a common occurrence in comic illustration and is a good example of compressed folds. Notice that the folds crisscross among themselves and there are some larger folds and some smaller ones interspersed. Since there is no fold origin point, you must determine how you want the folds to look and work on them to your satisfaction.

In the illustration of the little girl's feet (pge 60), two socks contain the tightly compressed folds. Because the folds have more of a horizontal straightness to them, similar to the extension folds, there is no looseness, or sagging, in the clothing.

ADDING SHADING

Because comic art is drawn solely with lines, it is difficult to show shading in folds. By using or combining crosshatched (discussed on page 115) and tightly compacted parallel lines, you can create the illusion of shading and make the folds and drapery more believable. Importantly, these lines can still be inked and reproduced in comics. Look back at all the examples in this chapter, and see how I shaded the folds. Try it for yourself when you do the following exercises.

Exercise:
DRAWING COMPRESSED FOLDS

Look closely at photographs that have compressed folds in clothing. Notice the different ways the folds cross over the body and each other. By tracing these folds many times over, you can easily draw them on your own in a short time.

Compressed folds consist of main folds with smaller folds alternating between them.

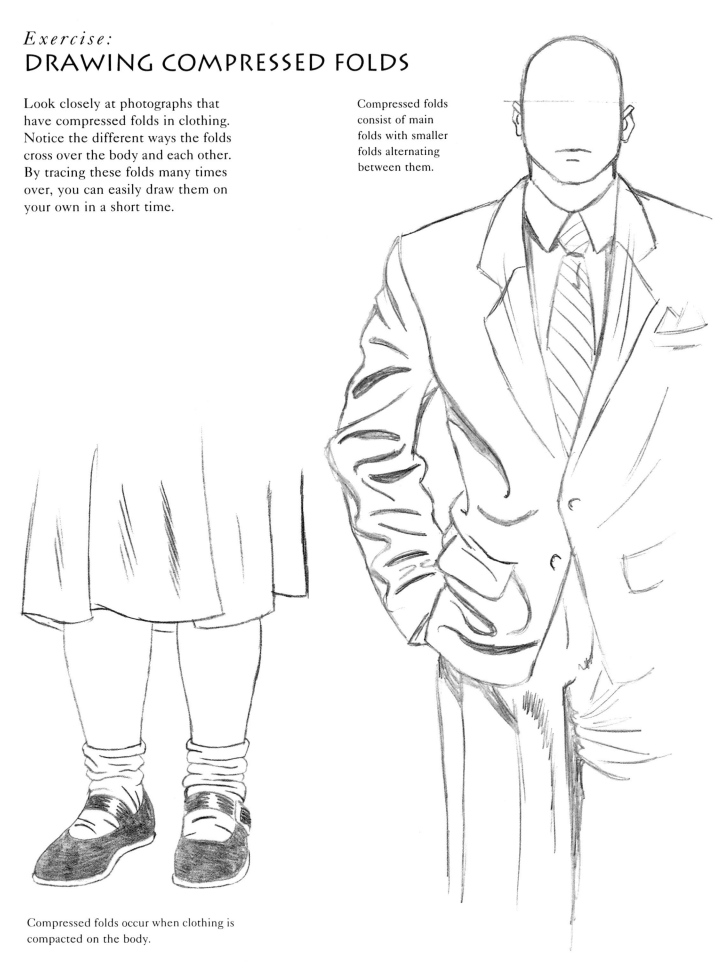

Compressed folds occur when clothing is compacted on the body.

KEEP IN MIND

• After you have gained experience with tracing figures, you should draw live figures and their clothing. It's good to work from catalogs or other photos, but real-life models are still the best subjects. If it is difficult for you to see how folds fall on a live model, close one eye, which will give you two-dimensional vision instead of three. With two-dimensional vision, you will see more of how the figure will look as a drawing on a flat surface.

• Certain patterns recur in particular types of clothes. Men's suit jackets, for example, have distinctive fold patterns that happen often in normal movement. These will become well known to you and easier to draw from memory as you gain more and more experience.

• One *very* important thing to remember: Don't overdo the folds; it only makes the artwork more difficult to understand and less appealing to the reader's eye.

• Always keep in mind that observation is the best teacher. Look around you and think about what you see.

Exercise: IDENTIFYING FOLDS

Search through comics and see if you can find all the different folds we have covered. Look the artwork over thoroughly, and identify gravity folds, extension folds, joint folds and compressed folds. When you feel you have a good grasp of these folds, observe your family and friends. Examine their clothing and try to determine which folds occur when they are doing normal, and maybe not so normal, tasks.

Exercise: DRAWING FOLDS FREEHAND

Now that you have all eight tracings done, take each one of the catalog photographs and draw each figure on a separate sheet of bristol board. Since you have a good idea of how the folds fall from tracing them, you should be able to draw them freehand much more easily.

Exercise: DRAWING FROM LIFE

With your bond paper pad, a bunch of pencils and erasers in hand, visit a mall, park or other public place. Find a nice comfortable place to sit and look around. Examine someone who is staying in one position for a while, and draw that person. Study the folds of his clothing. Determine the fold origin point for each group of folds, and concentrate on how they extend from there. As you draw the folds, don't skimp on the anatomy; this will help you improve that aspect of drawing as well. Do this for about eight to ten people. The more you draw, the better.

Exercise: TRACING FOLDS

Go through your catalogs and find two examples each of gravity folds, extension folds, joint folds and compressed folds. Be sure the photographs are large enough for you to study and work with easily. After you have chosen two good examples of each type of fold, lay tracing paper over each photograph and trace each entire figure. Give extra emphasis to the folds you are working on, but don't skimp on the figures themselves.

KEEP IN MIND

• The most important thing to remember is that drawing clothing and drapery is not an excuse for not drawing the figure first. Just like in reality, if there is no body under the clothing, the clothing doesn't take a recognizable human form. Many young artists fall into the habit of "covering up" bad anatomy drawing or being lazy when drawing clothing. The clothing then be-comes "bad drawing" as well. So, by taking the easy way out, your art-work suffers.

• There are no standard formulas for drawing folds and drapery. Folds can happen in any form or direction, so don't try to conform to any particular pattern. Eventually, you'll find yourself drawing certain kinds of folds and wrinkles so often that they become second nature and you'll be able to use them many times over. Keep in mind that the best teacher of drawing is your own observation. Look around. Look at catalogs. Walk through the mall and carefully study how the clothing drapes over people's bod-ies. Observation is the best teacher—and it's free.

JOE GIELLA DISCUSSES CLOTHING AND DRAPERY

• "The best piece of advice that I could give anyone about learning folds and drapery," explains "Mary Worth" artist Joe Giella, "is *learn to see*! Don't try to draw from memory. You learn by looking at things and studying different materials like silk, leather, denim and all the other fabrics. Every time you see something, put it down. Draw it out. That is the way you will learn how to draw the folds and drapery.

• "Later on you can render the clothing with more detail. Don't overdo the folds in the clothing. You don't want the reader's eye to go directly to the folds because the action might be in the character's face. But you also don't want the clothing to be open and empty.

• "Photographs are a great teacher, but you must learn how to interpret them. There can be a lot of ugliness in a photograph, so you have to be able to simplify it to eliminate the ugliness. Do this by constantly drawing and knowing what you want to create and what you want to use from a photograph.

• "All this is done by observing, studying and *repetition*. Constantly keep drawing. That is what en-riches your memory and makes your drawing continuously im-prove."

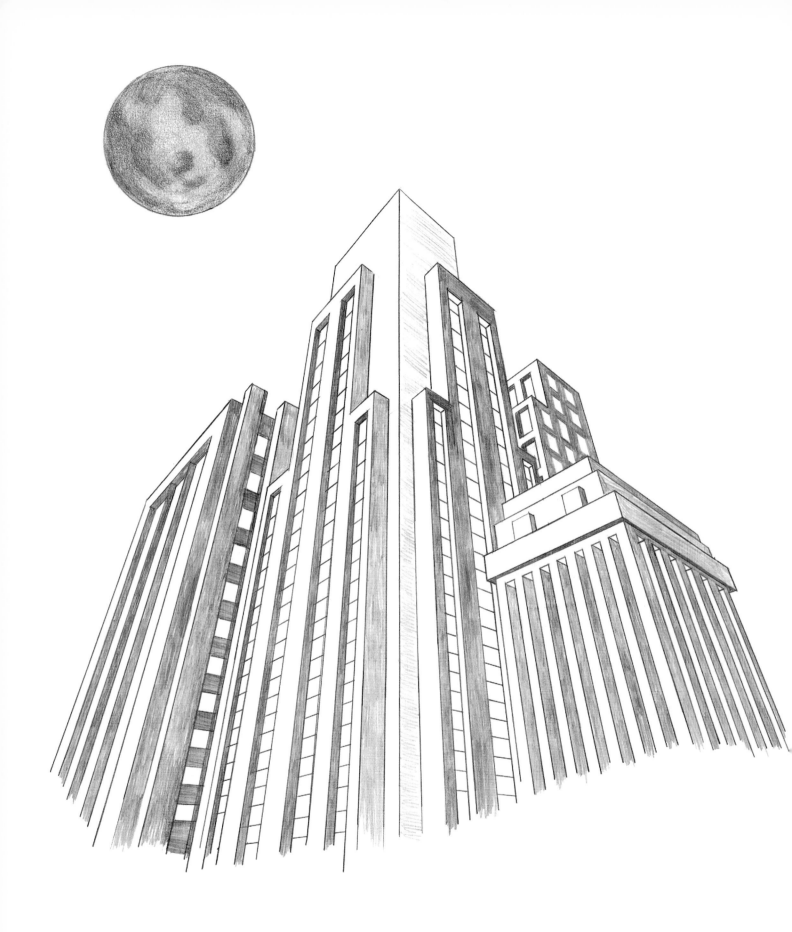

PERSPECTIVE

Now's your big chance to tackle and master the key element that makes your comics look believable—perspective!

The use of perspective is the way you make an image on a two-dimensional sheet of paper look three-dimensional. In other words, it's how you give your subject shape, form and substance. Also, you can create a background that looks like it's a mile and a half away, a middle ground that looks as if it's ten yards away and a foreground that seems to be right in front of you.

Drawing "in perspective" isn't very difficult, but you do need to study the principles of perspective in order to fully understand how it works. Once the concept clicks in your mind, there is nothing you can't draw using perspective.

HORIZON LINE

There is one major term you absolutely must know when working with perspective—*horizon line*. The horizon line is what every aspect of perspective revolves around. It is an imaginary line that runs horizontally through everything you draw as well as everything you see. *The horizon line is placed at the eye level of the viewer.* Think of the beach and the thin line that is created where the ocean meets the sky. That's the horizon and the narrow line separating the two is the horizon line. Keeping in mind that the horizon line is at the eye level of the viewer, if you crouch down close to the sand, the horizon line gets closer to the ground; and if you climb up on the lifeguard's bench, it gets higher.

With this simple bit of knowledge, you will soon be able to draw any scene and make it look as though you could walk right into it.

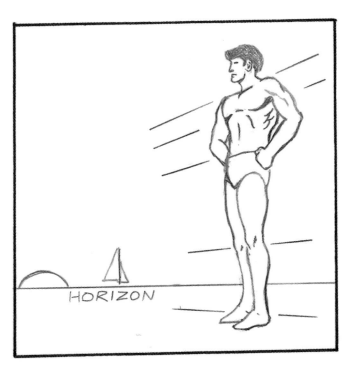

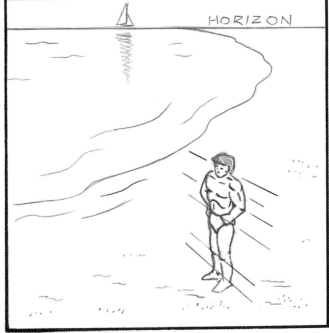

The horizon line is placed at the eye level of the viewer, whether he is close to the ground or up in the air.

ONE-POINT PERSPECTIVE

Let's start with the simple one-point perspective, which is the easiest kind of perspective to draw. You've probably done it thousands of times without even knowing it.

As you know, a square is two-dimensional: It has height and width. But a cube is three-dimensional because, along with height and width, it also has depth. That doesn't mean it is in perspective. It simply appears to have three dimensions.

It is a little tricky to add perspective to a square. To turn a square into a cube in perspective, you begin by drawing a horizon line on a sheet of paper using a ruler as a guide. Then draw a square *above* the horizon line. To turn the square into a cube in perspective, position your pencil lead on the horizon line directly under the center of the cube. This point is called the van-

ishing point. From this point, draw a line to each corner of the bottom of the square. Then, to establish the back edge of the cube, and create the cube's bottom, draw a horizontal line at any point between the two vanishing point guidelines you just drew. Be sure this horizontal line is parallel to the bottom edge of the cube. Now erase the portions of the vanishing point guidelines that extend from the horizontal line you just drew to the vanishing point on the horizon line. You now have a cube that exists in a one-point perspective environment. By using the same method, you can draw a cube in one-point perspective *below* the horizon line, which will show the *top* of the cube. Or, by placing a vanishing point on the horizon line *offset* from the center of the square, you can draw cubes that show their right or left sides.

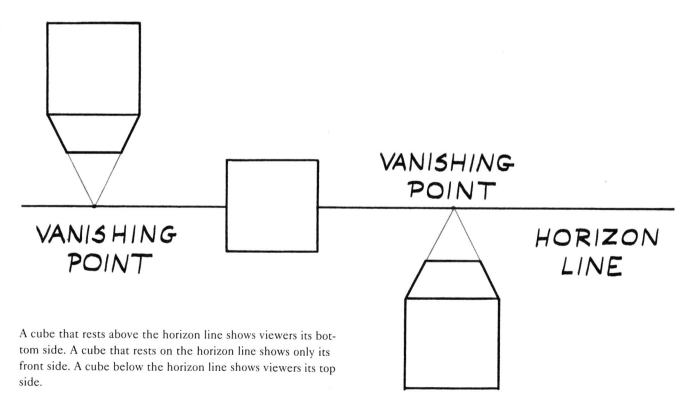

A cube that rests above the horizon line shows viewers its bottom side. A cube that rests on the horizon line shows only its front side. A cube below the horizon line shows viewers its top side.

KEEP IN MIND

• It's helpful to remember the rule of "opposites": When an object is *above* the horizon line, you will see the object's *bottom*, and when it is *below* the horizon line, you will see the object's *top*. When the vanishing point is offset *left* of the object's center, you will see its *right* side, and when the point is offset *right*, you will see the *left* side.

• One-point perspective means that you use a *single* vanishing point on the horizon line. Below is a scene that's drawn much more elaborate than simple cubes to show you how one-point perspective can work wonders for your art. It looks complicated, but it is no different than the simple cubes you drew earlier. Examine the scene closely. Notice the single vanishing point in the center of the horizon line that's running horizontally through the scene and all the guidelines connecting to that vanishing point. The fact is, all the buildings in this scene are just a bunch of cubes that utilize one-point perspective.

I told you it was simple.

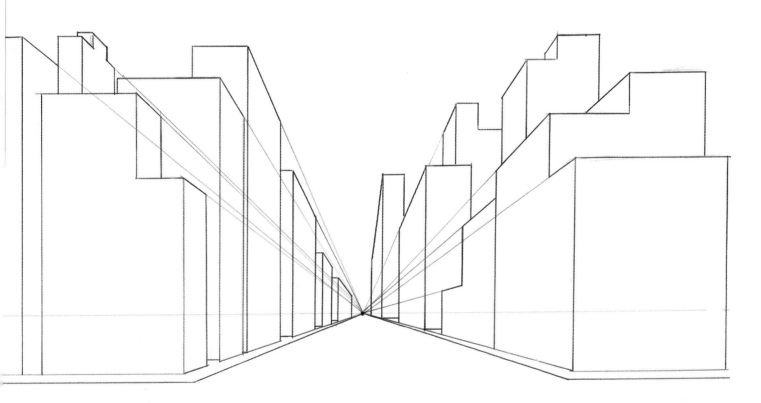

Notice how the horizon line runs horizontally through this entire scene.

TWO-POINT PERSPECTIVE

One-point perspective works just fine for many scenes, but let's put another vanishing point on the same horizon line and create two-point perspective.

In the illustration below, you see three cubes that utilize two-point perspective. Each one has a horizon line and on each horizon line are *two* vanishing points. The same principles that you learned about one-point perspective apply here. The only difference is that the objects in perspective don't directly face us but are angled.

The top cube is below the horizon line so you can see the top of it. This is the point of view you would apply if your character was in a tall building looking down on a building below.

The middle cube overlaps the horizon line. Notice that you can't see the top or the bottom of the cube, but the top and bottom edges still recede to the vanishing points. This viewpoint duplicates what your character would see when looking straight ahead.

The bottom cube is above the horizon line, creating the illusion that you are lower than the cube. This is the effect you would want in your drawings if your character were looking up at something, such as a ceiling and its lights.

The cube lines were drawn darker than the vanishing guidelines so you can see clearly and understand how the edges of your object in perspective connect to the appropriate vanishing points. These lighter guidelines are eventually erased when a perspective drawing is completed.

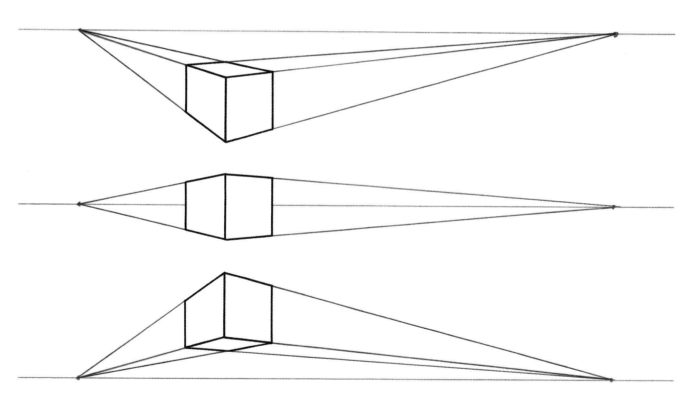

Guidelines show you how to connect objects to the two vanishing points in two-point perspective. Whenever possible, draw guidelines all the way to the vanishing point.

Now, let's take this rather simple idea and implement it, making something a little more complex.

The figure to the right shows a panel with a city building, which is really nothing more than a box with fancy designs to create windows. This panel has no horizon line drawn in and no perspective guide-lines drawn to the vanishing points. All of the guides have been erased. See if you can figure out where the horizon line and vanishing points are. To make it a little easier, place a sheet of tracing paper over the il-lustration and use your ruler to po-sition these elements. Now check your results.

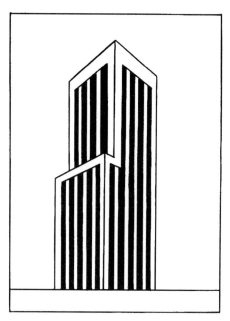

Can you determine where the horizon line and vanishing points are for this illus-tration? Compare your ideas against the illustration below.

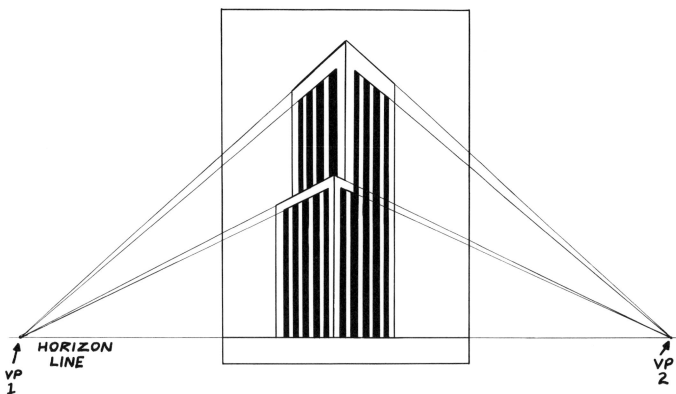

HORIZON LINE

VP 1

VP 2

KEEP IN MIND

• When drawing in perspective, you don't have to draw the perspective guidelines all the way to the vanishing points. The vanishing points are just for you to know where to place your ruler so the angles of the object will be correct. Drawing the guidelines slightly past the edge of the object is enough.

• Remember that you can only have one horizon line for each scene or panel.

Okay, you still haven't taken perspective to the limit, until now . . .

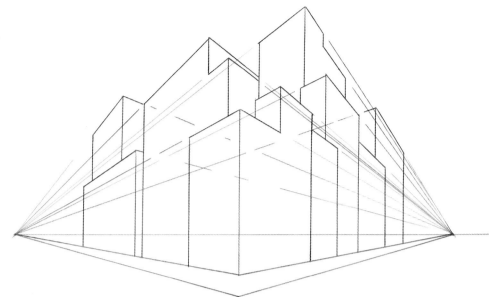

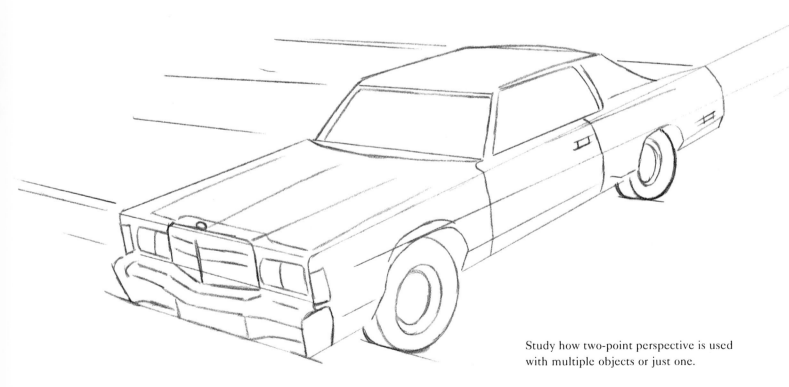

Study how two-point perspective is used with multiple objects or just one.

THREE-POINT PERSPECTIVE

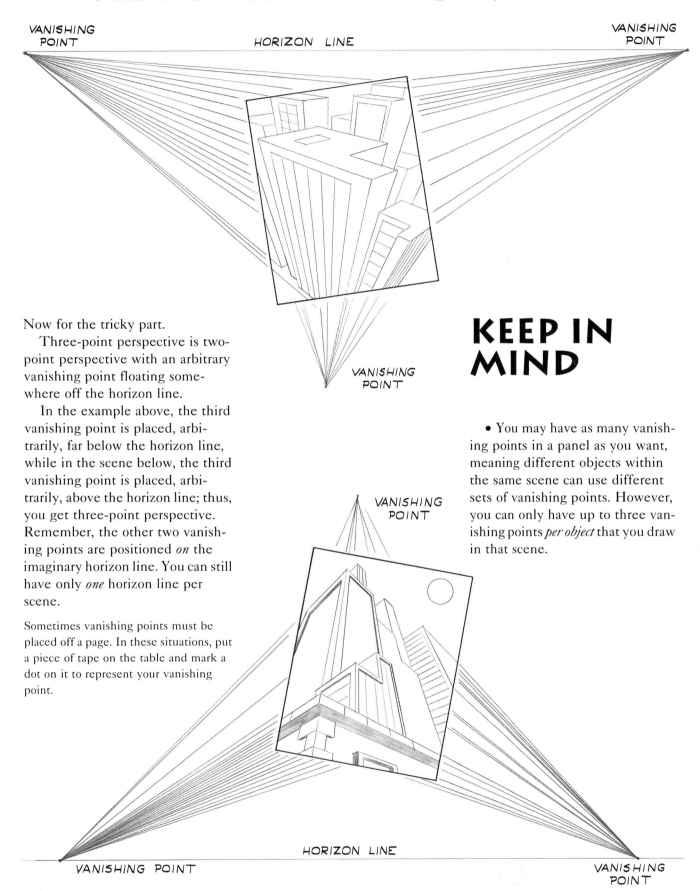

VANISHING POINT

HORIZON LINE

VANISHING POINT

VANISHING POINT

VANISHING POINT

HORIZON LINE

VANISHING POINT

VANISHING POINT

Now for the tricky part.

Three-point perspective is two-point perspective with an arbitrary vanishing point floating somewhere off the horizon line.

In the example above, the third vanishing point is placed, arbitrarily, far below the horizon line, while in the scene below, the third vanishing point is placed, arbitrarily, above the horizon line; thus, you get three-point perspective. Remember, the other two vanishing points are positioned *on* the imaginary horizon line. You can still have only *one* horizon line per scene.

Sometimes vanishing points must be placed off a page. In these situations, put a piece of tape on the table and mark a dot on it to represent your vanishing point.

KEEP IN MIND

• You may have as many vanishing points in a panel as you want, meaning different objects within the same scene can use different sets of vanishing points. However, you can only have up to three vanishing points *per object* that you draw in that scene.

OTHER OBJECTS IN PERSPECTIVE

Besides being an extremely important tool for drawing buildings, perspective is very helpful for drawing other objects.

CYLINDERS

Let's start with a simple cylinder. This cylinder could eventually become a smokestack, by elongating it, or a car's tire, by keeping it very shallow. Whatever you choose it to be, it must be drawn in perspective so it looks as if it has depth.

Begin with a square and a circle/oval within the square, both drawn in perspective (right). By adding depth to the square—making it into a cube—you can then add a second circle/oval just inches above the first. Now you have a very short cylinder in perspective. Small circles placed in the center of the cube, following the same rules as for the larger circles, give you a tube or a tire. As long as you create the squares first and make the circles fit inside, you will have no trouble creating any type of cylinder in perspective. This is a very important trick to remember.

PEOPLE

What about people? There will be many times when you want to draw people in perspective. Without perspective, your figures will look flat and lifeless.

Every time you look at people, they are in some sort of perspective,

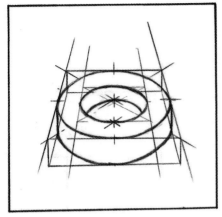

Even circles need to be in perspective sometimes. When you add thickness to a circle in perspective, it can become a chimney stack or a car tire.

although it may be more noticeable in some situations than in others.

The following figure drawings show the human figure in perspective using only basic geometric shapes. The figures on page 73 show foreshortening in action. Foreshortening is when you draw your subject in greatly exaggerated perspective. Since comic art is an exaggerated form of illustration, every cartoonist must know how to draw the foreshortened figure to give it as much exaggeration as possible.

Rest assured that *all* the rules for perspective that apply to buildings and other inanimate objects apply to the human figure and to foreshortening. Take a close look at the following art, and try to identify all the elements of perspective you learned about.

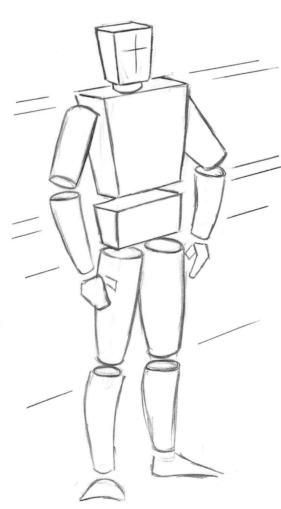

Every time you look at someone, she is in some sort of perspective.

 The use of extreme perspective is called foreshortening.

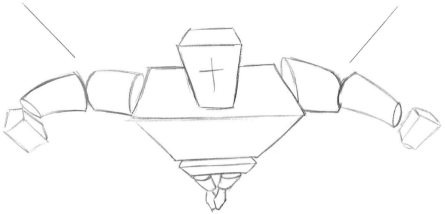

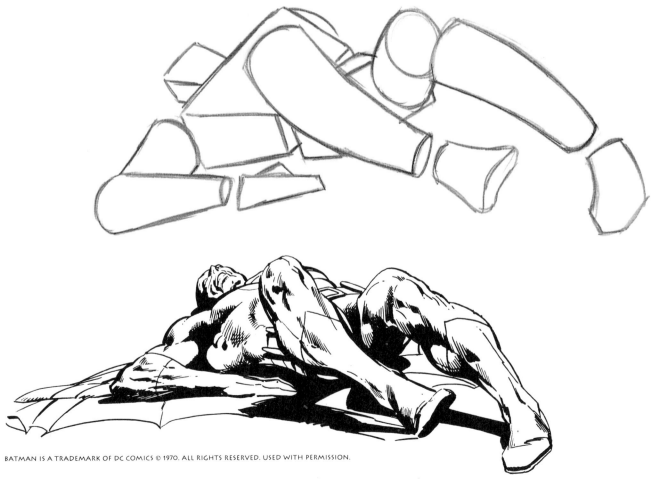

KEEP IN MIND

• It is always more fun to draw a superhero figure than it is to draw a milk bottle, but that milk bottle is just as important as the figure and should be drawn correctly.

• Drawing objects from real life will teach you infinitely more than copying objects from someone else's drawings. That does not mean that copying is bad. Copying is one of the best tools for learning how to draw, but use every chance you get to draw from real life.

• Perspective is a technique that should not be taken lightly. It is very difficult to make paper or board look three-dimensional, but once you master that, your comics will be incredibly believable.

Exercise:
IDENTIFYING THE HORIZON LINE

Look through a bunch of comic books and determine if there is a horizon line in each panel, and if so, where.

Exercise:
CITY SCENES IN PERSPECTIVE

Sketch a number of city street scenes utilizing one-, two- and three-point perspective. Use your neighborhood, school buildings or office park as your subject.

Exercise:
PEOPLE IN ACTION

Sketch ten panels in perspective that contain people on the city streets engaged in different activities.

FRANK SPRINGER TALKS ABOUT PERSPECTIVE

• "The first thing to realize is that everything in the universe that you can think of is a variation of the cone, sphere, cylinder or cube," advises Frank Springer, who draws "Hedley Kase."

• "Start by buying a cone, sphere, cylinder and cube at an art supply store, setting them up on a board under a constant light source and drawing them. Make sure the objects don't appear to occupy the same physical space in your drawings. These exercises might not sound exciting, but they are the best way to learn spatial relationships, perspective, light and shade. It might take a while, but you will get it.

• "When you have finished, look at your drawing, and ask yourself: Does that really look like four objects that are in a three-dimensional space, or does it look like a bunch of lines that don't mean anything? Does it have real depth to it? Is your drawing a real representation of the true-life objects?

• "The key to being an artist is, at some point in your head, to grab onto the idea of what something *ought* to look like. Have all the elements in your drawing representing real-life events. If you draw an apple, look at the drawing, then look at the real apple and ask, Does my drawing really look like something you can eat, or does it look like a lumpy piece of coal? This will help you develop a critical eye for your work.

• "When you can learn to represent something realistically, then you can go on to exaggerating what is real—that's where cartooning takes place. Still-life drawing, drawing objects from real life that don't move is a great exercise in learning perspective because it

helps you understand how things are supposed to look. It also helps you draw things that appear where they should. Everything has to look right for it to be right. As long as your drawings look correct, then they are.

• "When you are drawing a panel, a lot of the time you don't have the room on your paper to actually draw all the guidelines for the real vanishing points, so you must draw your lines as close as possible to where you think the vanishing points should be to make it look correct. In most cases, you will draw your guidelines approximately

where they should be so, for example, the people in your drawings who are standing by an automobile are sized correctly. You want to avoid one figure looking like a giant and the other looking like a dwarf.

• "If you go through the work of creating the perspective of your panel with mathematical precision and it turns out looking wrong, then it is wrong. Sometimes you will have to make your best 'visual' guess as to where your guidelines should be so that your comics look correct. And many cartoonists do just that."

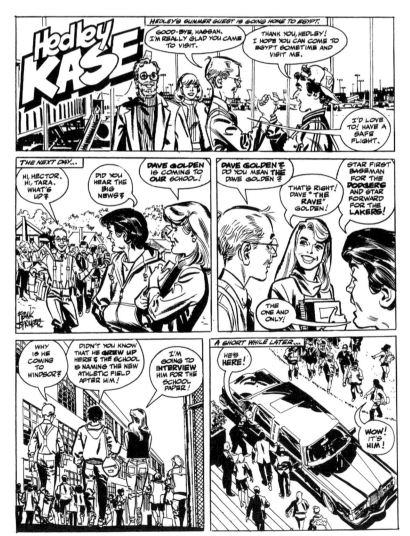

HEDLEY KASE © FRANK SPRINGER.

CHAPTER SEVEN

COMPOSITION

Composition is the one aspect of comic creation that many people don't even think about until it's too late. Composing a comic book page, strip or illustration so it is understandable to the reader is vital to the life of that comic, and it's up to you, the adventure cartoonist, to do this. The simpler you make the composition of the artwork, the easier it is to understand and the more pleasant it becomes to read.

Note: You may hear composition referred to by different names, such as layout or design, but they all mean the same thing: how the story is put together visually.

Visual storytelling is the foundation of comic art. Without it, all you have is a novel. When creating adventure comics, it's important to realize that *you* control what the audience sees. You have the power to make things exciting or boring. You have the power to make the story fast paced or slow. You have the power to make the audience continue reading or drop your comic like a hot potato. But the most important thing to remember is that you must tell a story and keep it flowing. All of this is part of the composition of a comic.

Of course, you want your audience to be excited, motivated and eager to grab the next edition of your comic. This happens because of composition!

It has been said many times by many people in the comic business that good art (especially composition) can make a bad story good, but bad art can make a great story horrible. This is what you want to keep in mind while you are learning about composition.

One way to describe composition is by describing a motion picture company. A movie company has many people working in various areas to make its picture the best one of the year. The same thing goes for comic artists. You and your comic characters have to be *all* of the people in your "motion picture company"—the director, actors, cameramen and others. This all boils down to good composition. Good composition consists of your characters being the actors and you being the director, cameramen and crew. To win the Oscar, everything must be "picture perfect."

CAMERA ANGLES

Let's start with camera angles. In the movies, camera angles are very important in telling a story and making it interesting to watch. The same applies to comics.

Comics' camera angles go beyond that of movie companies. A movie company is limited to where the camera is located due to normal space and mass. There are only so many places a movie camera can fit. But in comics, it is all in your imagination. Since there is no limitation to physical space in comics, the camera can be located *anywhere*. That is the advantage we have over movie companies; however, don't disregard the ability to learn about camera angles from watching good, and even bad, movies.

To begin with, imagine a panel with a telephone ringing and a girl looking at it (page 79). There doesn't seem to be anything wrong with this shot. It could be just about anyone on the phone. We have all seen the same thing hundreds of times in real life. But if you change the camera angle, the same telephone is ringing and the same girl is looking at it but the entire mood has changed. Someone could be on the other end who is about to tell the girl some disastrous news.

This type of camera angle is good for exaggerating the information you want to give to the audience. Not only will it change the mood of the setting, but it could also be used to really let the audience know what is ringing. With the shot in the previous panel, the ringing could be coming from the telephone, but there is a slight chance the audience might think it is coming from the doorbell or maybe even the ice-cream truck driving by outside the house. In the panel with the close-up of the telephone, there is absolutely no misunderstanding as to where the ringing is coming from.

As a more extreme example, look first at the panel (page 79) showing two men arguing. It's obviously a minor argument, and they will probably go out for a bite to eat afterward. The next illustration uses a different camera angle and a little action in their bodies to show that these two men are about to have the fight of their lives.

Take a little time this week to watch a few different types of movies. For example: Watch a romance and an adventure movie. Watch them carefully, but don't concentrate on the story. When watching the movies, look carefully at the cinematography, that is, the way the camera operators photographed the film. By using different camera angles, a movie director can make you feel different moods in a picture, even without sound. Studying how movies and television shows are made is something you might want to get in the habit of doing, because it will help you considerably in creating interesting comics.

As an artist, you are responsible for composing comics that are visually exciting and compelling to the reader.

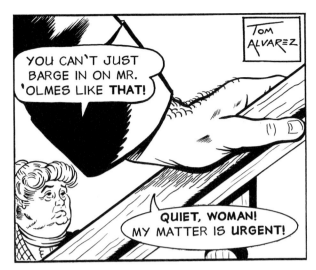

There are virtually no limitations on where you place your point of view in a comic panel. It can be an extreme close-up, such as shown (left), or a bird's-eye view, (right).

Average views make everything look—well—average. To get the readers excited, make the camera angle or view exciting.

When situations are to be average, the average view works well. But when the situations in your comic heat up, make them powerful by using interesting views.

DIRECTING THE VIEWER'S EYE

Composition in comics requires the skill of being able to direct the viewer's eye to where you want him to look. This may sound strange, but it's true. In comics, there are elements of the story that are very important to see, so it's up to you, the artist, to make the readers see what they are supposed to. This is done by using the techniques of camera angles, as we have learned, but it also consists of a few rules you must know to keep the reader's eye flowing through the comic page or strip.

It's well known that everyone reads English the same way: You start at the top left, read to the right and then drop down to the next line. This continues until you finish the page at the bottom right. The same way of reading is done in comic books. You start at the top left panel and finish at the bottom right. But composing this type of comics page is a lot more complicated than just reading. You must create a comfortable flow to the page. At least one element in each panel must direct the eye to the next panel and so on.

On page 81 is an excellent example of comic page composition. Irv Novick has done a wonderful job directing the readers' eyes through his "Batman" pages. Here's how it works:

PANEL 1: Batman swings from a noose upward, toward the second panel.

PANEL 2: Batman begins to swing backward, but his cape helps to continue the flow of the eye up toward the body from the previous panel. The legs then take the reader to the next panel.

PANEL 3: The position of Batman's body brings the eye to the torch, and the black wall acts as a barricade so the eye doesn't fall off the page. The speed lines (the lines showing the swinging motion under Batman's feet) move the eye to the panel below.

PANEL 4: This is an odd-shaped panel, yet it does the job well. The flame brings the viewer down to the feet, legs and then the bottom, left panel.

PANEL 5: The rope continues the visual flow down to the body and through to the cape. At that point, the speed lines and legs bring the eye right back up to the next panel.

PANEL 6: Using black as a background gives a good change to the viewer and a nice balance of black and white to the page. The handle of the torch aims up to panel seven.

PANEL 7: Batman is in full view, and nothing is directing your eye out of the panel. His head and rope aim the viewer to the next panel.

PANEL 8: The solid black gives a good feeling of continuity with panel six. The hands complete the story on this page; however, the fact that the body is falling out of the panel to the upper right encourages the viewer to turn the page. A well-composed page directs the eye through it and guides the viewer to the next page, or by directing elements toward the center of the final panel, it communicates to the reader a sense of finality.

Exercise:
DISCOVERING GOOD COMPOSITION

Examine the comic pages on pages
82-83 and identify compositional
elements that guide you from panel
to panel.

Notice how your eye is directed exactly where the artist wanted it to go in this page. Speed lines in the center of the [right] panel help direct the eye toward the action.

By directing elements toward the center of the final panel, you can give the reader a sense of finality.

USE NEGATIVE SPACE

Even though you must include a lot of information in a panel so a character's location is apparent, sometimes "less is more." After setting your locale and characters, you choose to put negative space around a character by leaving the background out of a panel or positioning a character stand in an area of black. Negative space gives the reader's eyes a bit of rest and, when done correctly, is effective and can be dramatic. But don't overdo it, or your comic could end up missing too much information. Below are some examples of how Dan Barry utilized negative space to its fullest in two "Flash Gordon" strips.

There are many different design tricks you can use to enhance your pages and strips. One is to jut elements out of a panel or as in the case (bottom left), include some subject matter to separate the panels.

Backgrounds aren't always needed to give a sense of the dramatic.

Panels can be separated by objects other than gutters.

™ & © 1996, MARVEL.

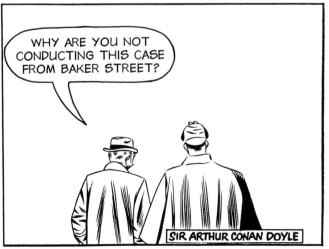

Here, a black background, or negative space, is used to its fullest effect.

Sometimes less detail creates a more effective composition.

CREATE FAST LAYOUTS

An excellent way of creating good composition for your comic strips and books is by laying out an entire page design on a small sheet of paper, as shown below. This lets you develop the basic idea of the script while figuring out the best design for the page. Shown here is a page of fast layouts. Examine it carefully and see how the artist told the story without using word balloons in the comic. Notice that even though these are all fast, rough sketches, they are all in the proper proportions. Also, the backgrounds were added so the artist knew the camera locations and angles before he actually finished the final pages.

Once you become experienced with composition, good layout designs will come naturally. You will get to the point of not even thinking about how to make your work flow; it will just happen.

After reading the script, your layout can be composed on small sheets of paper very quickly. Sketchy layouts help design a comic without wasting time and paper.

Exaggeration, such as of a panel's shape, helps to dramatize a story.

KEEP IN MIND

• A good rule in learning how to compose a comic page or strip is to remember to never direct anything *out* of the page or strip's outer border. By this I mean don't show a character pointing to the left in a panel that is located at the top left corner of the page. This directional action by the character will cause the reader to want to look off the page. Show the character pointing *toward* the next panel or, if it's on the right side, pointing toward the previous panel. If you remember this rule, you will never lose the eye of your viewer. The exception occurs when you want a character in the last panel on a page to direct the viewer to the next page.

• As you continue, it gets a bit trickier. When you are penciling a spread (two pages next to each other, usually divided by the spine, or center fold, of the book) whatever is happening in the bottom right panel of the left page must direct the eye of the viewer up to the top left panel of the next page. This is a difficult skill to master, but once done, you will have the smoothest comic pages around.

• Look at some different companies' comic books and see how other artists direct the readers' eyes. Now that you know what you are looking for, you will be more conscious of how they achieve this and, in turn, be able to do it in your own work.

• Close-ups and long shots are very important to telling a story. Don't skimp on them.

• When dealing with close-ups, make them visually interesting. Don't simply zoom in on a character. Show your audience what that character is feeling.

• Each panel should work alone and with the others. Composition isn't just telling a story; it's making it exciting to read, too.

Exercise:
STUDYING WELL-FILMED MOVIES

Watch a good movie, and draw a panel of each scene in the movie. If people are engaged in dialogue, draw two panels for that scene, one for the initiation of the conversation and the other for the response. Copy exactly how the director filmed it. If you have a VCR, you can easily use a freeze-frame while you copy. Remember to make each pencil drawing a finished panel. These should not be sketches.

This exercise will help you to show people holding conversations.

Exercise:
IMPROVE EXISTING COMICS

Get any comic book and redraw, in pencil, the entire book, making every page better than the one that is there. You may redesign the pages any way you wish. When finished, your book should be visually better than the original.

Exercise:
TRANSFORM A STORY INTO A COMIC

Choose a short story by your favorite author, and draw as many pages as it takes to complete the story. Basically, create a comic book from that story. You may place word balloons, but don't worry about lettering yet.

LARRY LIEBER TALKS ABOUT STORYTELLING THROUGH COMPOSITION

• "When describing how comics are created," says Larry Lieber, "Spider-Man" and "Incredible Hulk" illustrator, "I'd use the word 'storytelling' rather than 'composition,' because you're trying to tell a story. The question for the artist then becomes, What's the best way to tell the story? Outside of comics the closest storytelling medium is a movie, which uses close-ups, medium shots and long shots. You use these same techniques to try to tell your story in a comic, with your ultimate goals being clarity and maximum dramatic effect.

• "One of the best people at storytelling in comics, if not *the* best, is Gil Kane. Look at his old comic books if you want to study storytelling composition. The reason I mention Gil is because he played things up so interestingly and well. If he had a long shot, it was a long panel going down the side of the page.

For example, if a guy was falling off a building, Gil showed the whole building and a little falling figure rather than a close-up of the guy and a window that he happened to be passing. This composition created a full, dramatic effect. This is the sense of the dramatic and the visual that you have to develop. That's why I say watch the motion pictures, especially the old westerns, because of all the compositional and storytelling elements they use.

• "Look at a lot of comics and decide who you think tells the best story, visually, and

then figure out why. Since comic artists don't compose pages the same way, it's good for you to figure out how you like a story told and work from that. If you constantly ask yourself, What's the most dramatic and interesting and unusual way I can draw this? you'll do well."

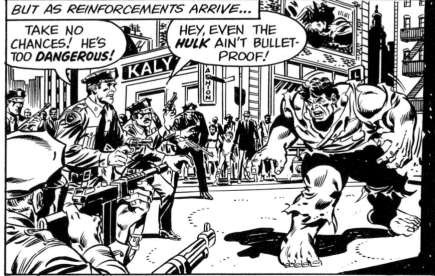

BUT AS REINFORCEMENTS ARRIVE...

TAKE NO CHANCES! HE'S TOO *DANGEROUS!*

HEY, EVEN THE *HULK* AIN'T BULLET-PROOF!

DRAMATIC LIGHT AND SHADE

Most people take light for granted. Since everyone is used to seeing things illuminated from above, no one thinks twice about light. Whether it's natural light from the sun or artificial light from 60-watt bulbs, almost all light shines onto a subject from above. All this is fine; however, the events in comics don't often happen in everyday life. So you must create light sources that are rare and exciting. This will give your comics that extra bit of "difference" that readers are not used to seeing and, in turn, will make your comics more interesting to look at.

DETERMINE YOUR LIGHT SOURCE

After you have broken down your panel and just before you draw all your details, determine where your light source is. A light source illuminates the subject matter in your panel. It could be the sun, a fluorescent light bulb or an incandescent light bulb. These types of light sources are basic and usually shine from above, creating a standard lighting effect in your panel. Some scenes you may draw with these types of light sources are people talking in an office setting, walking down the street on a nice summer day or washing dishes in a kitchen. All these scenes are ordinary and require ordinary lighting effects, but when you get into the unordinary is when the lighting gets much more interesting.

UNORDINARY AND UNREAL LIGHTING

An unordinary scene could show a mad scientist working in a lab with the only light coming from the butane torch that's brewing his weird concoctions. Or, perhaps, two people eating dinner by candlelight. Or, better still, an old-time, gold miner walking through a cave with a torch in his hand. These are out-of-the-ordinary light sources because you rarely see them; however, they are real sources of light illuminating the subjects of your comics.

Now let's imagine some unreal light sources. You can create fantastic moods in your comics by creating an imaginary light source that could never exist but looks good for what you want to do. Let's say your character is so angry he is ready to burst. You may emphasize this anger by shining light directly in the center of his face as if a bulb is right in front of him. No matter where that person is, it's unlikely that a light source is right in his face, but you have the power to do this so your comics will be more exciting and emotional.

LIGHTING EFFECTS

No matter what type of lighting effects you want, you can choose from or modify these basic styles: silhouette, single light and multiple light.

SILHOUETTING

Silhouetting is the simplest lighting effect to understand because it depicts a solid black form on an illuminated background. In the case of a silhouette, the light originates from directly *behind* the subject, that is, in the background. As a result, the subject is drawn completely black because no light is illuminating the front of the subject. Silhouetting produces a dramatic feeling.

Using silhouettes is not a way to cheat or to get out of drawing your figures or subjects. The same amount of drawing needed to complete an entire figure *must* be used on the form you plan to put in silhouette. Once drawn, you simply fill the entire area in with black ink during the inking stage. If you take a shortcut and only draw the outline of the figure, thinking you'll fill it in with black ink later, you are shortchanging your own work. Although the details of the subject are not seen, your reader can envision exactly what it looks like. A well-drawn figure in silhouette can be just as pleasant to look at as one drawn in normal lighting. If you try to get around drawing all the information within a figure just because it will be a silhouette, your figure will not look as natural or "real" as it could.

One extremely important rule when working with multiple silhouettes is to never overlap them. A silhouette is easy to understand if it is simple. Once you place multiple silhouettes on top of each other, you lose the ease of recognition of each silhouette and it becomes a big blob of black.

MINIMUM LIGHT

Using minimum light takes a silhouette a step further. The subject contains mostly black but has small amounts of highlighting on areas you want to emphasize. In a minimum light scene, the light source is still behind the subject, as it is in a silhouette, but is now placed slightly off to one side. Take as much care drawing a minimum light subject as a full figure in normal light. Determine where to place the highlights by imagining, as best you can, where you think the light hits the subject. Nonhighlighted areas become solid black.

Minimum light can be very dramatic when used properly. Drama, depression, sorrow and similar emotions are well expressed with minimum light. Many times a writer-artist can use minimum light instead of words to describe the feelings of his characters.

A silhouette is any object that is solid black, indicating that it is being illuminated from behind.

Silhouettes can change the pace of a comic.

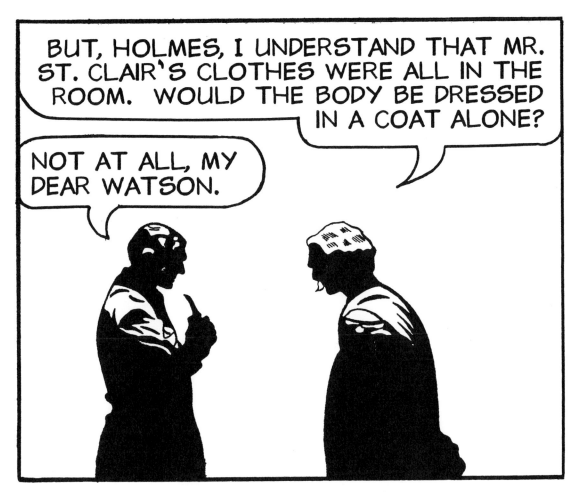

Minimum light adds drama, and only a few highlights, to the subject.

SINGLE LIGHT

Single light is probably the most commonly used lighting effect. While everyone is used to seeing people and objects illuminated by a single light source emanating from above, the unusual comes into play when you move the light source. For example, using a lantern as your single light source can create the feeling of loneliness and despair, while a single spotlight can project a thrilling and powerful emotion. A light shining from below the chin onto a person's face creates torment and threat. The emotion you achieve depends entirely upon where you place your single light source.

MULTIPLE LIGHT

Using multiple light is the most difficult technique to master be-cause you must keep track of exactly where each light source originates and how it affects the other light source(s).

Just as with any other type of lighting effect, when used properly, multiple light can produce many different emotions in your readers, which helps make a comic good. Most of the time, multiple light involves one major light source—natural or artificial—illuminating the subject from one direction and another, less intense light source illuminating from the opposite direction. This second source could be another natural or artificial light source or the light from the first source reflecting off a surface and back onto your subject in an indirect manner. It is totally up to you as to how you wish to play with light in your artwork.

Single light is the most commonly used.

DOUBLE-ENDED LIGHTING

Another multiple light effect is double-ended lighting, which uses two equally intense light sources shining onto the subject from opposite directions. Note: The use of equal-intensity light sources distinguishes double-ended lighting

This cover shows two equally intense light sources illuminating from opposite sides of the subject.

HALFTONING

In all lighting effects, some form of halftoning is used to create the illusion of light curving around an object, to depict shadows and to give your subject form. Although light travels in a straight line, as shadows fall, they gradually become darker the farther they move from the highlight, or "hot spot." At the penciling stage, halftoning is accomplished by shading with the side of your pencil, darker and darker as you move farther away from a highlight. But because you need pure blacks and pure whites for final reproduction, you must ink the shading in your final art. Since black ink doesn't let you show the variations of gray that you achieved with pencil, use the shading techniques, such as feathering and cross-hatching discussed in chapter ten, "Inking."

Another way to show that shadows darken when moving away from standard multiple lighting. When using this effect, never shade your subject exactly the same on each side that is illuminated. Light could never fall on both sides of your subject in the same way, especially if it's a person, since no subject is exactly symmetrical. You must show some shading differences on each side even though the light intensity is equal.

The most important point to remember when working with multiple light sources is to watch the effect of each light source on your subject and each other. Make sure each light source doesn't interfere with the others, or even counteract them.

Practice rendering different lighting effects by sketching very loosely.

from a highlight is with halftone "screens," available at well-stocked art supply stores. These screens are mechanically printed with tiny black dots that get closer and closer together as the shadow darkens. Mechanically produced screens print as black dots on the white comics page, so they reproduce well for comics. The big drawback to using screens is that they are so mechanical you don't want to use them on anything that is organic or natural looking. Screening a chair or lamp is fine, but screening someone's face isn't. A face has curves and planes that screens just can't "curve" around. You are better off feathering or cross-hatching on faces.

PLAN YOUR LIGHTING

The most important thing to remember is to finalize your light sources during the pencil stage. If

Halftone screens make objects look more mechanical.

you place light on your subjects haphazardly, it will look that way when inked, and your readers won't understand what you're trying to say with your art. If you place your light thoughtfully, it will make your work more dramatic and visually easy to read.

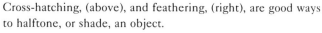

Cross-hatching, (above), and feathering, (right), are good ways to halftone, or shade, an object.

KEEP IN MIND

- The less light you use, the more dramatic the mood becomes.
- Any chance you can, draw from an accurately lit subject by setting up a model with the light source you intend to use.
- Use light to your advantage. Don't just slap a light in because you can.

Exercise:
PICTURE TAKING

Using black-and-white film, photograph objects such as fruit, small toys and other inanimate objects that are lit with a strong light source, such as a lamp. Change the angle and direction of the light for each picture. Play around with the light and see what effects you can produce.

Exercise:
DRAWING YOUR PHOTOS

Using your photographs, draw each of them and include all of their lighting effects.

Exercise:
LIGHTING ON FIGURES

Draw five different figures utilizing each type of lighting effect discussed in this chapter. You may use real models, magazine photographs or drawings, but don't copy another artist's lighting effects. If you do copy a predrawn figure, be sure *you* determine all the different aspects of lighting yourself. Remember to use a different figure for every drawing.

Exercise:
REVERSAL DRAWING

On a black sheet of paper, draw *in reverse* some of the objects you have photographed. To do this, use a white pastel pencil and draw the white, or highlighted, areas instead of the black, shadow areas. This will help you understand how light actually works on three-dimensional objects. Do this for about ten objects—more if you can.

SY BARRY DISCUSSES LIGHTING

• "One of the most important secrets in art is that the eye doesn't look at the dark areas; the eye looks at the white," notes Sy Barry, illustrator of "The Phantom." "All of the areas of a form that fall away from light are in shadow. There is practically no drawing involved with the areas that meet the light. You, as the artist, draw everything that falls in shadow. That's what all drawing is. That's what all art is. That's what all form is. The artist simply breaks down the areas of light by showing the effects of light (the shadows) on the form.

• "A marvelous thing for a young artist to get involved in is photography. With photography, you set up lighting, with a primary light on one side of the form and a secondary light on the other side. You see the principles of light and shade being played out. Using a form as simple as an orange, you can see where the greatest amount of light hits, where the primary and secondary highlights are, where the primary shadows and halftones fall. You can also see where and how the shadows change when you move the lights around the subject. For example: A direct overhead light source will give a very simple pattern of light.

Notice how as the shadows darken, the adjacent highlights become stronger or how a bit of reflected light can appear on the opposite side of the subject from the light source.

• "Photography is such an important learning tool. It not only helps you understand light and shade, but it helps you learn how to draw and work with composition. If you take time to set up your photographs, they will teach you how to place your items in your panels so that your drawing will be more interesting to look at."

LETTERING

The biggest falsehood in comics is that lettering is unimportant. Quality lettering can make a poor strip look good, and bad lettering can make a great strip look terrible. Having said that, keep in mind that lettering can go unnoticed when it is done well, simply because it doesn't draw your attention away from the artwork or the story. Poor or improper lettering can make a reader lose interest in a strip for many reasons. The lettering might be confusing, distracting or just plain illegible. If a person can't read the text of a strip, you lose that reader forever.

Just as drawing is an art, so is lettering. You cannot just pick up a pen and be ready to work on a strip or book. In the past, people were given the job of lettering simply because a company was desperate and needed an immediate letterer. This doesn't happen much today. Publishers realize the importance of quality lettering. They now look for letterers who can complete the job with a high degree of professionalism. There are letterers who have spent years practicing for their particular jobs. And remember that the term *lettering* doesn't simply stop at the alphabet. A letterer is also responsible for the placement of the balloons, captions, titles, credits, bubbles, sound effects and just about anything past the actual artwork that helps tell a story. The illustration on page 98 shows some of the different effects a letterer adds to a strip or book.

Before we get into the actual techniques of lettering, let's go over some of the tools. As I mentioned in chapter two, there is certain equipment that is particular to lettering. Along with the tools, there are particular terms that you, as the letterer, must know. We will examine these throughout this chapter.

Before you can begin to letter, you must know where and how large to write. Comic strips or pages don't have guidelines to show you where to place your letters or even how big to make them, so you must create your own guidelines.

STANDARD LETTERING SIZE

We will start with the standard size of comic strip lettering. Since all comic lettering is done with capitals, you needn't worry about lowercase size. The standard size for newspaper comic strip lettering on original art is three-sixteenths of an inch, or what is more commonly called 18 points. (A point is a form of measuring, but because the increments are very small, you can produce very accurate sizes, which is important with letters.) The point measuring system is also used to indicate line thickness. For example, a 1-point line would be like the thickness of a line drawn with an extrafine felt-tip marker.

USING AN AMES LETTERING GUIDE

The Ames Lettering Guide (page 99) is like a fancy ruler that lets you draw lettering guidelines and, eventually, specific size letters. The wheel in the center turns so you can adjust how tall your letters will be. There are many holes in the wheel that let you create multiple lines at once instead of constantly moving the guide. Here are steps for drawing lettering guidelines.

1. To begin, for standard 18-point comic lettering, you must adjust the wheel to the proper setting, which is 6. Simply line up the number 6 on the wheel with the short, vertical line just below the wheel.

2. Place a clean sheet of bristol board on your drawing board and get out your T-square. Your T-square will keep your lines perfectly parallel. Place the Ames Lettering Guide, face up, on the top edge of the T-square, and insert a well-sharpened pencil or, even better, a technical pencil, into the top hole of the evenly spaced row of holes, which has the number 10 directly under the bottom hole.

3. Drag the Ames Lettering Guide across the entire width of the paper, keeping it taut against the T-square. This gives you a single straight line across the paper.

4. Skip a hole, insert your pencil into the next one and drag the guide backward along the T-square, drawing another line. You now have two guidelines, between which you will place your lettering.

5. Since one line of text can't rest directly on top of the line of text below it, you need to create a line space between the text guidelines. To do this, *do not* skip a hole; instead, insert your pencil into the very next hole and draw a line to the right across your paper.

6. Skip a hole and draw your next text guideline backward across your paper. Continue to create your text lines and your space lines until you have filled up your paper.

7. When you have used all the holes in the number 10 row, move the T-square down on your board to start a fresh group of lines. Use the bottommost line you drew previously as a guide to begin your new group of lines. Use the Ames Lettering Guide to be sure that your lines line up properly by overlapping the last line you drew before with the first line you will draw now. The new line should perfectly overlap your previous line. Then you know the lines are parallel.

8. Save this lined board to practice lettering.

Different typefaces communicate different meanings or moods to readers.

LETTERING TOOLS

Like any other aspect of comics, lettering requires its own tools. You can't letter with an inking nib just as you can't ink with a typewriter. For lettering, you will use a Hunt Speedball B-6 pen nib, as well as whatever pen holder you feel comfortable with. There are basically three different pen holders you may choose from. Each one has a slightly different shape. Try each to find the one that's the most comfortable for you. Along with the pen nib, you'll use standard black India ink.

Before starting to letter, think back for a moment. When you create a comic, there are certain steps that must follow in sequence. It's the same with lettering. You must pencil in all letters in their spots before you ink them, just as you draw a comic before you ink it. The penciled letter forms not only serve as guides for inking, they are also correctable.

An Ames Lettering Guide lets you draw perfectly sized lettering guidelines quickly.

1/8 inch spaced holes for title blocks etc.

Direct setting for cross-hatching

Grouped sets of guide lines

Finish mark symbol

AMES LETTERING GUIDE
OLSON MFG KANSAS CITY KS U S A 68°

The second row from the right on the Ames Lettering Guide is the one you use for comic lettering guidelines.

This line is 1 point thick.

This line is 2 points thick.

This line is 4 points thick.

THIS TYPE IS 12 POINTS TALL.

THIS TYPE IS 14 POINTS TALL.

THIS TYPE IS 18 POINTS TALL.

THIS TYPE IS 24 POINTS TALL.

Here are typically spaced lettering guidelines.

LETTERING PRACTICE

On this page and page 101 is an entire alphabet, including numbers and punctuation. Notice the arrows around each item. These arrows show you the proper pen strokes to use in creating each letter. Study these strokes carefully.

Using the guidelines you made earlier, practice each letter, number and punctuation mark one at a time. Letter lots of them. Work on each one until you feel you have a good grasp of it and all of your samples of that letter begin to look similar. Create as many new pages full of guidelines as you need. Fill up page after page with letters. Be sure you follow the pen strokes that are given. Finally, create words and then sentences but, for now, continue to do so in pencil only. If you need more room to practice, simply take a new sheet of paper, use the Ames Lettering Guide to draw new guidelines and continue.

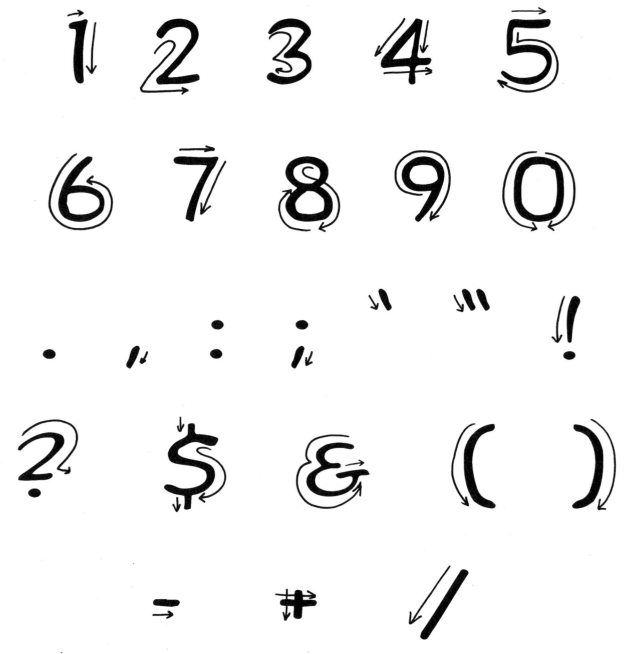

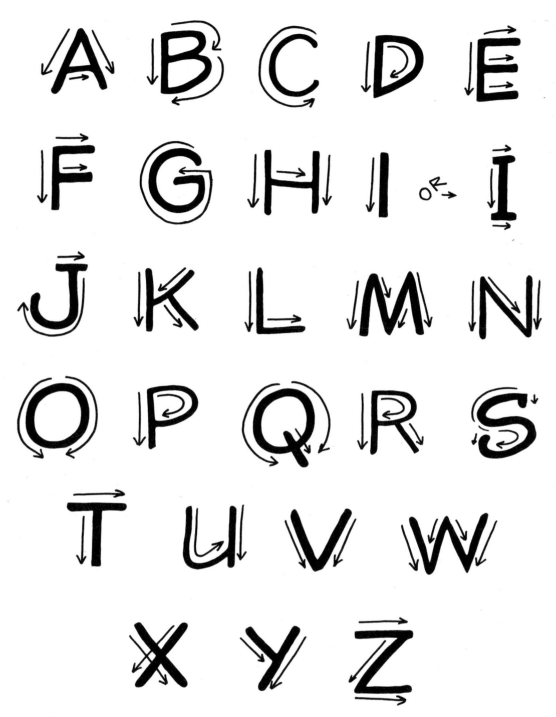

Draw the strokes of each letter and number in the direction the arrows indicate.

Exercise:
DETAILED PRACTICING

Now you can pull all that hard work together. Starting on a new sheet of paper, create new guidelines using the Ames Lettering Guide as you did before. Make up a short, nonsense story, and letter it out in pencil. To see how well you can coordinate your letters, make the story fit in a specific space of your own choice. A circle, square or any shape would be a good start. Don't worry about word (dialogue) balloons yet.

Your letters should be looking much better than on the first page you lettered. If you don't think they do, go back and practice some more. Remember, it takes a lot of practice to be a quality letterer.

To ensure proper letter sizing, be sure each letter touches both the top and the bottom guidelines.

Exercise:
FINISHING PENCILED LETTERS

Open your ink bottle, get that pen ready and go at it! Ink all the letters you created in the two exercises above. Be sure they are consistent and neat. Try to stay on the pencil lines and use the same lettering strokes. This is the type of practice you should spend many hours on if you intend to letter for a profession or for your own work. It's not easy, but with practice you will impress the most critical editor.

Ink each letterform uniformly.

WORD BALLOONS

A letterer's other major responsibility is the creation and placement of word balloons. Balloons are actually indicators for the readers. They tell the reader who is saying what and how they are saying it. A character could be thinking something to herself, yelling to a friend or whispering to a child. Each of these situations is indicated by a different type of balloon. The most common is the simple encircling of the dialogue. There are also whispering, shouting and thought balloons. The various balloon styles and their proper usage are illustrated below.

Also shown are many different ways lettering will be used in a comic. Each one is labeled so you know what it is called and what it is for. Try all of these in many different ways to get a feel of how to create them.

Practice lettering this title and sound effect to develop your skills and confidence.

KABLOOM!!!

THE SECRET 7

THOUGHTS ARE SHOWN WITH THIS BALLOON.

BALLOON TAILS ARE FOR INDICATION OF WHO IS TALKING. THEY SHOULD SIMPLY BE PLACED IN THE DIRECTION OF THE CHARACTER THAT IS SPEAKING AND NOT DRAWN ALL THE WAY TO THE CHARACTER'S MOUTH.

BOLD LETTERS ARE USED WHEN YOU WANT TO **EMPHASIZE** SOMETHING.

THIS BALLOON INDICATES A CHARACTER IS **SHOUTING!**

THIS TYPE OF BALLOON AND SMALLER LETTERS INDICATES A CHARACTER IS WHISPERING.

WHROOMM

PLACING AND DRAWING BALLOONS

The above panel illustrates poor lettering placement because the word balloon covers up most of the artwork the story revolves around. The right panel works well.

Many people don't realize that letterers also have to be designers, due to the letterer's responsibility for placement of the balloons. Balloon placement is a serious job. If a balloon is placed in the wrong spot in a panel, it could cover up important visual information. At the same time, if a group of balloons in a panel are placed incorrectly, the story will not flow properly. It is as simple as one person saying one thing first and the second person responding. Incorrect balloon placement could show an answer before the question is even asked.

Balloons are placed in the same way we read: starting at the top left and ending at the bottom right. A balloon tail is that small pointer that sticks out of the balloon to indicate who is speaking. You should never cross a balloon's tail over a major character to point to the speaker.

Balloons are created in pencil on top of the penciled artwork. In this way, the portion of the artwork that is under a balloon is erased easily. If artwork has already been inked and lettering must be placed over it, the only way to do that is by lettering on a separate sheet of paper, cutting it out and pasting it down on top of the artwork. This process is not recommended but is often used.

Above are examples of good and poor balloon placement. Examine them well so you may avoid these mistakes when you letter.

CORRECTING LETTERING MISTAKES

Remember, as a letterer you are only human. You can spell a word wrong or forget a letter. That's where the good ol' Wite-Out comes in. If you must use correction fluid on inked lettering, use one that is non-water-based. Wait for it to dry, and re-ink right on top of it.

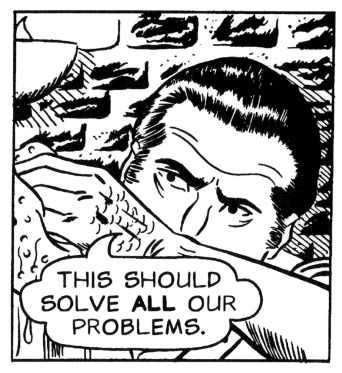

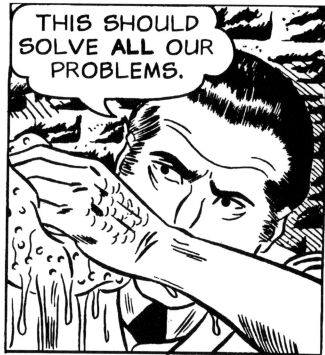

Here, the word ballon covers up what the character is doing with his hands.

The tails of word balloons should never cross.

KEEP IN MIND

• There are times when the letters of a strip or book will instill their own personality into the story. The best example of this type of lettering appears in Gary Larson's "The Far Side." His letters are by no means consistent and perfect, but they work. The poor lettering quality actually adds to the zaniness of his gags and originality of his art. Having said that, remember that you are learning about adventure comics. Adventure lettering should be clean, crisp, legible and, most of all, consistent.

• Consistency is quite probably *the* most important part of lettering. You may have a style that is thin, bold, slanted or any which way it

may be, but as long as every one of the letters is the same way, the style will work. It was once said that if the letters are bad but they are consistently bad, then that is good lettering. But, of course, the higher the quality of your letters, the better.

• It may be a problem for you to find the proper pen nibs, Hunt Speedball B-6, right away. If this is the case, then buy a medium-point, felt-tip marker and work on your letters with that (after the pencils, of course). However, try to acquire some pen nibs because they will give the letters a look that is unique to that tool. This goes for whatever pen nib you decide to use.

Exercise: LETTERING A STORY

Rewrite a short story from a famous author of your choice. But rewrite it in comic book lettering and in pencil only.

Exercise: INKING A LETTERED STORY

Use a different story and rewrite it in pencil first and then letter over it in ink. When you get through, erase the pencil lines to see how your inked letters look.

Exercise: LETTERING A COMIC PAGE

Make up a very simple story that will take up at least six panels. The story doesn't have to be incredible—just as long as there is dialogue. Illustrate the story in pencil utilizing everything you have learned from the previous chapters. Make it look exciting. When you have finished penciling it fully, letter it. Use the correct balloons and balloon placements. If there are any sound effects, put them in. Letter it in pencil first, and when you are satisfied with that, ink your letters to the finish.

AL SCADUTO DISCUSSES LETTERING

• "Lettering is a great way of getting into the comic business," says Al Scaduto, cartoonist of "They'll Do It Every Time." "For example, you could begin your career by lettering for a cartoonist and in time become *his* letterer. Then one time he's late on his work and he might ask you to ink in large areas of black for him. Next, he might need help on his backgrounds, and the next thing you know, you've become his 'assistant.' From there, many avenues can open up. But, of course, you must be a good artist, or it would stop right at the lettering."

• Scaduto's advice continues: "Always leave 'air' (space) around the inside of the balloon. Never get your balloon line too close to your lettering; it always makes the lettering look amateurish and difficult to read.

• "Don't get fancy with lettering. In reproduction, it becomes very difficult to read. Keep your lettering simple, straight and direct.

• "Good lettering should take on a gray shade if you blur your eyes and look at it. Don't read it, just look at it by squinting so your vision is out of focus.

• "An Ames Lettering Guide is an excellent tool. Use it to its fullest. It can help you greatly to make your letters look professional and legible.

• "You can do bad lettering and have it work for you as long as it's consistently bad. This may sound strange, but it works because all the letters are created the same way— badly. If the lettering is erratic and in different styles, it won't work. The reader will be confused by dif-

They'll Do It Every Time

ferent styles of letters in the same comic. He'll also have a difficult time reading it, get frustrated and put down your comic.

• "If your art skills are limited but you really want to be in this field, then concentrate on your lettering. You can make a good career in lettering and be in the field, with all the benefits.

• "The best advice I can give to anyone interested in lettering is buy a light fountain pen, work up to a dip pen, and letter and letter and letter and letter!"

INKING

As you have seen throughout this book, most of the artwork is printed in pencil form so you will become familiar with what that stage looks like. But, because of the deadlines and the need for cost efficiency in the printing of newspapers and comic books, the pencil lines must be solid black, otherwise they will just disappear on the poor-quality newsprint used for these publications.

Inking is the process of using a pen or brush to "trace" black India ink over the pencil lines so they may reproduce well. While inking may be a form of tracing, it goes much further than that. As an inker, you will work with a number of dif-

ferent pencillers, so you must know how to interpret finished penciled work. Some artists will draw very sketchy lines; others will pencil tightly by drawing every line exactly how they think it should be in the final art. It is up to the inker to determine which line will be the final, inked line in the finished comic. The inker must also be able to decide how thick the lines will be. Your job is to redraw the penciled work with ink. If you just "trace" over the penciled lines with just any old inking tool and not give much thought to your work, the finished comic will look flat and lifeless. Inking is a lot of work, but, if done well, it can make a comic sing.

Inking is its own art form.

An inker is as much an artist as the penciller or letterer. Some students of comics don't want to go through all the training necessary to be pencillers and, instead, think they can easily become inkers. *They are absolutely wrong.* You must first become a proficient artist and know all about drawing before you may even begin to learn how to ink.

The theory mentioned in previous chapters about the other stages of comic creation also applies here; A good inker can make boring pencils beautiful, while a poor inker could make beautiful pencils boring. It is the same rule throughout all of comics.

INKING TOOLS

As with any project, there are specialized inking tools, and different tools achieve different inked results. You may use one tool or a variety of tools to achieve the finished comic. No matter what you decide to use, be sure you know how to use each one to its fullest.

DIP PENS AND NIBS

The dip pen and pen nibs are the same type of pens that were used years ago for all-purpose writing. They are used in inking in quite the same way as they are used in lettering, only with different pen nibs. The most popular nibs today are the Gillott no. 1290 and the no. 102 pen nibs. The pen is used mainly for inking small detail, such as heads and hands, along with tiny objects on the page.

SABLE BRUSHES

The companion to the pen nib is the sable watercolor brush. The most popular brushes today are Winsor & Newton Series 7 sable brushes no. 2 and no. 3. They are more expensive than most others, but they are certainly worth it. My personal favorite is the Isabey Kolinsky sable brush no. 3. The hairs are a bit longer than Winsor & Newton's and a tad more flexible.

Although pen nibs and holders are cheap, when it comes to buying brushes, you'll pay more. As you are learning, substitute economical brushes for the expensive ones. The brush is primarily used to ink figures, along with filling in black areas. It makes the cleanest, most attractive lines for folds and drapery, but it excels when used on hair.

MARKERS AND TECHNICAL PENS

The final tools used for inking are the felt-tip marker and the Rapidograph technical pen. Using these tools was unheard of a few years ago, but styles and times have changed.

The marker and technical pen are rigid, so you can't achieve the variance of line that you can with the brush or dip pen, but the markers and technical pens do have their place. They are excellent for background detail, borders, perspective and to achieve a "scratchy" look. The markers and technical pens come in sizes from extrafine to broad. Since they can't give a thin-to-thick-to-thin line, they should be used to ink more "architectural" items.

When you begin inking, start with the more exact and precise lines of architecture, warming up to the looser, free-flowing lines of more organic objects.

The Gillott no. 1290 pen nib offers great line variance because of its flexibility.

The more rigid Gillott no. 102 nib allows much less line variance.

A sable brush can ink anything the pen nibs can and much more.

A marker or technical pen allows no line variance and is best suited for inking architecture or mechanical objects.

INKING SAMPLES

Study the artwork on the right. The penciled panel shows a guy giving his girlfriend a big kiss. The panel is simple and to the point. There is only a little bit of background in the panel but just enough to get a feel for where the characters are located. There are plenty of folds and figures and a good amount of hair.

The panels on page 113 are inked versions of the penciled one. The first three panels have been inked separately using a different tool in each panel, and the fourth panel uses all the tools in ways that best enhance the art.

This first panel was done solely with a marker/technical pen, and as a result it's kind of flat and lifeless. We want more. There is no differentiation between the lines and, especially, with the quality of each line. Everything is stagnant. That's something we would expect from the background but not from the flowing hair of a pretty girl, the facial features or the folds of the clothing the characters are wearing.

The second panel is inked with a dip pen. It has much more life to it than the marker/technical pen panel, but there are certain areas, such as the background, that need more precise line quality. Forget about inking the solid black areas with a pen; that would take forever.

The next panel is inked with a brush. It's as lively as the one with the dip pen technique, but it's ex-

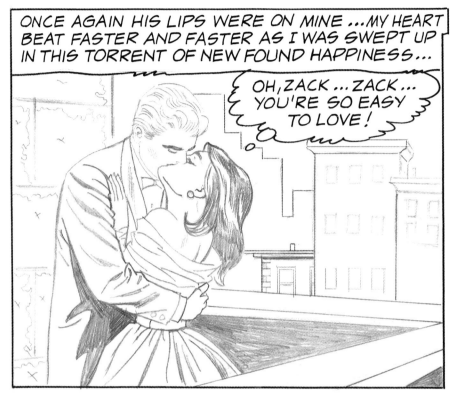

The *Xs* evident in the left-hand portion of this penciled panel tell the inker that these areas should be solid black.

tremely difficult to ink very small detail and straight, consistent lines (unless you become very good with the brush).

The last sample used all of the inking tools. This inking quality will make the penciller proud to have your inks on top of his art. Each element of the art has its own personality and works with the others harmoniously. The marker/technical pen was used for straight, consistent lines; the dip pen was used for small detail; and the brush for the rest (especially hair). It is just a pleasant picture to look at.

You had best be fluent in all three forms of inking (marker/technical pen, dip pen and brush) so you have the ability to ink many different forms of pencils as well as imitate a variety of inking styles. Joe Giella once told me, "I'd use a *mop* if that's the effect that I want."

This panel was inked using a marker/technical pen.

This panel was inked using a dip pen.

This panel was inked using a sable brush.

This panel used all of the inking tools to their best advantage.

KEEP IN MIND

• Always clean your brushes, nibs and technical pens with soap and water. India ink acts like an acid on the bristles of brushes. Since they are so expensive, you don't want to buy more of them than you have to. During your work, have a cup of water nearby so you can rinse out your tools in be-tween inkings.

• Don't get carried away with your inking lines. You can have too many inked lines in a panel. You will know this has happened be-cause your comics will look muddy and too busy. Don't use lines that are too fine because when the fin-ished artwork is reduced to be printed in a comic book or newspa-per, the too small lines will reduce so small that they will simply "drop out" (disappear) and not print.

• Inking takes a great deal of concentration. Be sure you are calm and comfortable while sitting with good posture at a firm table.

INKING HAIR

A bit of extra attention and practice should go toward learning how to ink hair. Hair is a tricky element to ink, but, if done correctly, you should actually see the silkiness of the hair. The number of inking lines in the hair determines the darkness of the hair. If the character is a blond, there are fewer lines, while in a brunette, more lines.

Although a dip pen can work well, the best tool to use when inking hair is a brush, but don't just dive into it. Look at a number of different inkers' styles, and try to copy them. Eventually you will develop your own way of inking—not only hair but everything else.

The number of inked lines you put into hair will determine whether your figure is blond or brunette.

INDICATING LIGHT SOURCES

There will be times where you, the inker, must indicate the light source because the penciller didn't. Imagine a simple illustration of people in an office. Everyone knows that the light comes from above, but you must indicate that with the inking. You would do this by inking thinner lines on the surface the light is hitting and thicker lines where the shadows fall.

SEPARATING THE BACKGROUND

It's also important that you make it appear as though the background is completely separate from the figures and the foreground. This is achieved by utilizing solid blacks, along with feathering, to separate the three areas.

FEATHERING

Feathering is where you make it seem that things are getting darker as they curve around a surface. Picture a ball lit by a strong light source. Feathered ink lines make it appear that the light curves around the ball, giving the illusion that the ball is round. You can get very detailed with feathering in your figures.

CROSS-HATCHING

Cross-hatching is feathering light around the surface of an object using a technical pen or felt-tip marker. By inking multiple parallel lines and then, at a different angle, repeating the process on top of the original set of lines, you acquire a look of shadow creeping across an object. The overlapping at different angles can be repeated until the entire area becomes solid black, but that extreme is not often used.

The parallel lines should be just that: parallel to each other but not necessarily perfectly straight. It is better to slightly curve the lines when cross-hatching on top of a natural object, such as a face or an animal, than to keep them perfectly straight. On the other hand, it is better to keep the parallel lines straight when cross-hatching on mechanical or metallic objects, such as machines or buildings. This

Feathering is used to render areas of an object where the lighting gradates from light to dark or vice versa.

There are times when an inker must determine the direction of the light source.

creates a more mechanical look.

Like everything else, cross-hatching takes a bit of practice to look correct. Examine other artists' cross-hatching techniques, and try to emulate them.

Exercise:
EXPERIMENTING WITH INKING TOOLS

Play with each tool: dip pen, brush, marker and technical pen. Get used to the way they feel in your hand and the types of marks they make. See what you can do with them. Also, use different types of ink with each tool, and examine the effects each one makes.

Exercise:
COMPLETING PANELS

Draw a bunch of panels and then ink them. Use different tools for different panels and observe the results. Don't be afraid to experiment; just be sure to pencil them on bristol board first to avoid problems like soaking through the paper or having the ink bleed where you don't want it. When working on these panels, don't avoid lettering.

Exercise:
INKING ON VELLUM

Lay vellum over figures in magazines and newspapers, and ink the figures. Include the backgrounds as well. See how your inking looks after you remove the vellum.

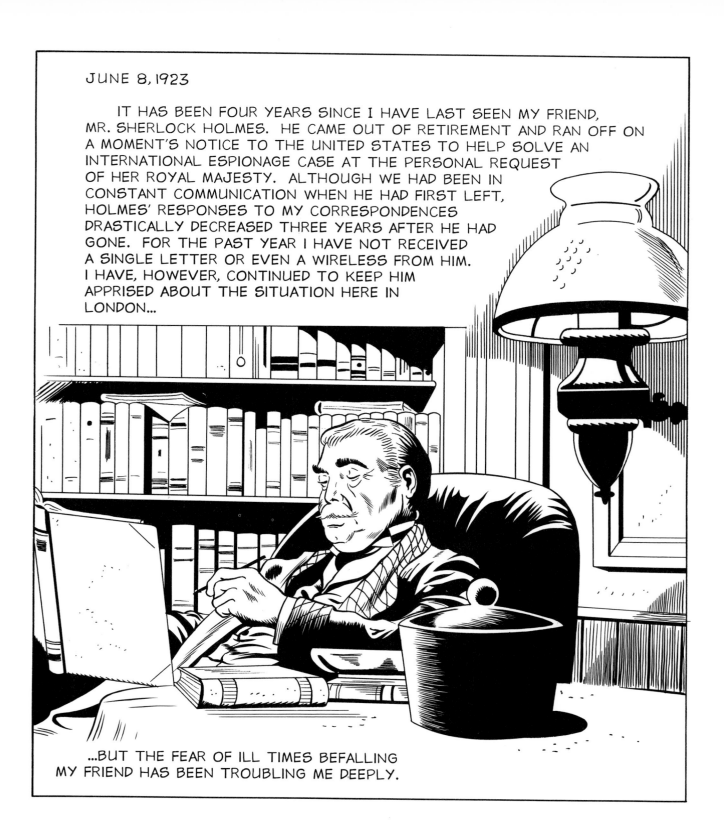

JUNE 8, 1923

IT HAS BEEN FOUR YEARS SINCE I HAVE LAST SEEN MY FRIEND, MR. SHERLOCK HOLMES. HE CAME OUT OF RETIREMENT AND RAN OFF ON A MOMENT'S NOTICE TO THE UNITED STATES TO HELP SOLVE AN INTERNATIONAL ESPIONAGE CASE AT THE PERSONAL REQUEST OF HER ROYAL MAJESTY. ALTHOUGH WE HAD BEEN IN CONSTANT COMMUNICATION WHEN HE HAD FIRST LEFT, HOLMES' RESPONSES TO MY CORRESPONDENCES DRASTICALLY DECREASED THREE YEARS AFTER HE HAD GONE. FOR THE PAST YEAR I HAVE NOT RECEIVED A SINGLE LETTER OR EVEN A WIRELESS FROM HIM. I HAVE, HOWEVER, CONTINUED TO KEEP HIM APPRISED ABOUT THE SITUATION HERE IN LONDON...

...BUT THE FEAR OF ILL TIMES BEFALLING MY FRIEND HAS BEEN TROUBLING ME DEEPLY.

WRITING

Although the *writing* of comics is actually the first aspect of comic creation, I placed this chapter toward the end of the book for one major reason: If you are a writer, *you are a writer!* There is no jumping back and forth from writing to art back to writing.

Many pencillers are able to ink and even letter their own work but, with the exception of creating gag comics, few artists write their own adventure stories. Frank Miller exemplifies those who can, and it's worth studying his work, but I would advise shying away from trying to do it all. I say this because if you can't do it with an incredible amount of success, you will only be wasting your time.

Writing is a career on its own. It's also very cut-and-dry—your stories must be exciting for readers to desire to read them. Imagination is the most important element of writing. Using your imagination, you must come up with ideas that will keep readers on the edges of their seats, dying to read the next page. Just as an artist practices her craft night and day, and continues to improve the quality of her art, so must you as a writer. Read as much as you can. This will help you develop your imagination to the point of creating your own story lines. But that's only the beginning. You may be inspired by another story or an event, but turning that into a successful plot and script is the trick. It takes a lot of time and hard work, but you can do it.

When people hear "comics," they immediately think visually. But comics are much more than that. While the artwork is very important to comics, the story is the most important element. The artwork may pull the readers right in, but it's the story that keeps them reading (and buying) your comics. Readers will tolerate poor lettering (as long as it is legible), they will even put up with inferior art, but if the story is written badly, you will lose reader interest fast.

WHAT EDITORS EXPECT

Editors are very conscious of putting together the best quality elements in their comics. They want superior art, clean lettering, sharp inking and, of course, great stories. And it doesn't stop at the editors. Readers are demanding all the above as well. So the pressure is really on for you as a comic creator. This is why editors have many people working on one comic book or strip. They find the best creators for each component of the comic and put them together to create it. This way the comic ends up being the best it can be.

WRITING TOOLS AND STORY PRESENTATION

No editor in the world will even bother to look at a comic script unless it is typed. Although you keep track of ideas longhand, most editors want a double-spaced, typed copy of a script so it is easy to read and has plenty of room for the insertion of comments. Each company even has its own format you must follow if you want the editors of that company to read your scripts. We will go over the most popular ones later in this chapter.

A typewriter is good for writing scripts, but let's face it, that's the early seventies' way of working. Today, a word processor is the key to writing. It makes everything faster and easier so your ideas can flow in any direction without you having to worry about Wite-Out or tearing out a sheet of paper in frustration.

Since there are millions of personal computers in homes around the world, a word processing program is easy to come by. Even if you don't have a personal computer, you can purchase a word processor for about the same price as a regular typewriter. So there is no excuse. With a word processor, you will have a hard time losing your train of thought. You just type feverishly and later rearrange your words the way you want them.

I'm not going to teach you how to use a word processor; that's up to the manuals and you. I just want to stress the importance and ease of its use.

SCRIPT TERMINOLOGY AND FORMATS

Specific terms are used in script-writing to guide artists. Most of the time the writer simply tells the story (along with the dialogue) and the artist interprets it the way he feels it works best. There will, how-ever, be times that you, as the writer, will want a particular per-spective or look to the scene. In these cases, you must describe what you want the artist to draw.

Long Shot (aka Panoramic View or Es-tablishing Shot): A view that shows a great deal of information, usually about the background. It is used often to set the location of an event.

Close-Up: Usually a zoom-in on a person's face or an important object.

Extreme Close-Up: One that is so tight you may only see the character's eyes. It is used to spark emotions in the reader or show detail of an object.

FRANNIE, STOP! YOU LITTLE FOOL!

ROWRR!

Worm's-Eye View: A camera angle from below, or from the ground, looking up.

Bird's-Eye View: A camera angle from high in the sky or at the very top of a building looking down.

MRS. ST. CLAIR, I AM SORRY BUT THERE IS NO EVIDENCE THAT YOUR HUSBAND WAS EVER HERE

Medium Shot: How we normally see things, an average view.

STAN LEE TALKS ABOUT WRITING

• "In order to be a good comic book writer you have to be a good writer to begin with," says Stan Lee, creator and writer of "Spider-Man" and "The Fantastic Four." "The ideal comic book writer should also be able to write a novel or a screenplay.

• "You have to know story, story structure and, most important of all, characterization. I've always found that writing action and dreaming of complications and villains and plots isn't too hard. If you can write, you do these things like falling off a log. The thing that I have to concentrate on the most, and I think every writer should, is characterization. Let's say that you decide you're going to feature a hero who is a doctor by day and the Masked Avenger by night. You still have to ask yourself, How am I going to treat this character so that the reader will care about him? Why should the audience really give a hoot what happens to the character? Why should they want to follow this story and not buy another magazine and read about somebody else?

• "To me, the only answer to this last question is that you must create an interesting character. For example: When I was a kid, I loved Sherlock Holmes. The mysteries were good, sure, but I was more interested in reading about Sherlock Holmes himself than in trying to figure out who the murderer was or who the robber was. You can buy a million books about murders and robberies, but you can't get too many books where the characters themselves are as fascinating as Sherlock Holmes. And the same goes for television. One of my favorite shows is *Columbo*. The stories are not that much different than any other crime stories, but Columbo I find a fascinating character.

• "So, as I say, the one thing new writers should concentrate on is characterization. Anybody can write a story. But how do you make the reader want to keep reading your story? The only way is to make characters so interesting that the reader cares about them. You have to breathe flesh and blood into your characters."

THE PLOT FORMAT

Scriptwriting falls into three major formats. The first, and the simplest, format comes from Marvel Comics and is called *the plot*.

Marvel's plots are written the way a short story is written. It begins as a "Once upon a time" type of opening and ends with a complete finish. There is very little or no dialogue throughout the entire plot and almost no description of how the writer wishes the artwork to look. An advantage to the writer for using this method is that after she writes the first plot and hands it over to the penciller, the writer can begin another story before she gets the first one back for dialogue completion.

The plot method of scriptwriting stirs up differing emotions in the pencillers associated with the work. Some pencillers enjoy working from this type of script because it allows them complete freedom in composing and illustrating the book. Other pencillers detest this format *because* they have to compose the entire book, breaking the story down to fit into twenty-two pages and then breaking each page down into at least six panels per page and so on. This can be very time-consuming and frustrating. If the writer or editor doesn't like how the book is laid out, it might have to be redrawn.

After the penciller finishes drawing the entire book, it goes back to the writer, who writes the dialogue in preparation for lettering.

Tom DeFalco
Amazing Spider-Man Annual #22
"DRUG WAR Rages"
Plot for 35 pages
First Draft: January 18, 1988
Page 4

Chapter Three
(Pages 11-17)

Headline... "Police Mount Spider-Hunt"
 That night, Spider-man returns to the warehouse. As he enters, his spider-sense warns him that he's not along.
 Daredevil is present. Immediately assuming that Daredevil is going to try to capture him, Spidey begins bouncing around...
desperately trying to convince DD that he is innocent.
 Using his ability to hear heartbeats, Daredevil realizes that Spidey's real nervous... but he's telling the truth.
 Spider-man almost can't believe his ears when DD tells him that he (DD) believes him (Spidey).
 CUT-TO: A Broadway play getting out. Present are Maddie and Robbie Baldwin. The cast invites their old pal Maddie to a cast party. Robbie tells her to go ahead, but he's heading back to their hotel. As Maddie goes off with her friends. Robbie wipes his brow...He's real glad he doesn't have to go out with his mother's friends. He's glad for the time alone...because he has some serious thinking to do.
 CUT-TO: The Daily Bugle. Jameson is proudly looking at his evening edition. He's finally got the web-swinger where he wants him. "Don't be too sure of that," Kate Cushing says as she enters the office. According to a daily poll, the public supports Spidey and his actions...the web-swinger has become another Barnard Geotz! Jameson can't believe his ears. He tells her to get her reporters...they've got to squash this public sentiment, and prove Spidey innocent!
 CUT-TO: Robbie walks along the city streets. He's real worried...thinking about his recent accident. He doesn't notice a gang of toughs which are following him.
 Suddenly, the toughs race to attack and mug him. In the

The plot style script, used by companies such as Marvel Comics, leaves full responsibility for page composition up to the penciller. This finished comic page shows the plot script "in action."

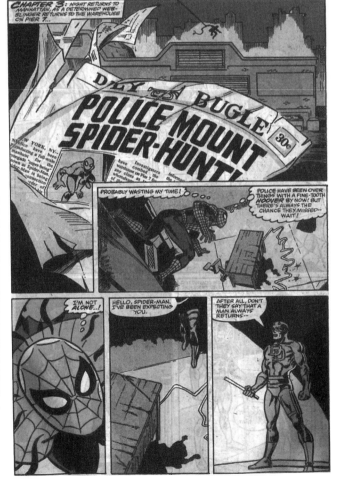

THE COMPLETE SCRIPT FORMAT

SPEEDY Chapter #1
ACTION COMICS WEEKLY #636
Mark Verheiden

"EXILES" PART I

Page 1--

Panel 1: A dark "living room". where our narrator-- Speedy/Roy Harper-- sits in an overstuffed chair, talking to someone off panel. He's in his "Roy" clothes in this sequence. This should be a moody, dark panel, with slits of light slashing across the room from backlit venetian blinds. Speedy's apartment is functional, but certainly not opulent. Any furniture or appliances we see in this sequence should be threadbare, cracked, etc. The unspoken implication of page 1 and 2 is that rascally Speedy is trying to talk some unsuspecting lady into bed. (it's not true, but that should be the implication.)

ROY: COME ON, BABE, IT'S LATE. LET'S GO TO BED.

ROY #2: ALRIGHT, ONE MORE STORY. THIS TIME I'LL MAKE IT A FUNNY ONE.

Panel 2: Like going through a photo scrapbook, we see "shots" from Speedy's past. In this panel, we see a young Roy Harper firing arrows into a distant target under the tutelage of Brave Bow, his Indian mentor.

CAPTION (Roy): "AND GUESS WHAT? I'M THE STAR. DON'T KNOW WHERE TO BEGIN, EXACTLY, BUT LET'S FACE IT-- I DID NOT HAVE YOUR BASIC CHILDHOOD."

CAPTION #2 (Roy): "I WAS ORPHANED AS A BOY AND LEARNED ARCHERY FROM AN INDIAN NAMES BRAVE BOW. THIS IMPRESSED THE HECK OUT OF A MILLIONAIRE NAMED OLIVER QUEEN, AND I BECAME HIS WARD."

Panel 3: "Action" shot of Green Arrow, bow ready, standing atop a building, ready to fire. Again, in keeping with the dark motif, let's have this action set at night.

The complete script, used by companies such as DC Comics, provides the penciller with full creative direction. This finished comic page shows the complete script "in action."

On the opposite side of the coin, there's the DC Comics form of scriptwriting, that is, the script is generally complete before it goes to the penciller. The complete comic script looks very similar to a movie script. It begins with a detailed description of how page one, or the splash page, will appear and then goes into a full-blown account of every page of the book. This type of script even goes so far as to break down the pages into individual panels. The dialogue between characters is also written out before the penciling begins. This helps the artist include space for the placement of word balloons and sound effects in the design of his pages and panels so that the letterer won't cover up anything important to the story when she letters in the text.

All the detail needed for a completed comic book is determined by the writer. After the writer completes the script, he doesn't have to work on it again unless the editor makes story changes.

This type of script is well liked by the writers because it gives them the most control over how the story will flow. Some writers go so far as to put in suggestions for how each panel should be drawn. When the comic book's script is finished, anyone could read it as a comic without having any pictures to look at.

The complete script is the most widely accepted form of comic scriptwriting in the industry.

Complete scripts evoke a great deal of controversy among the artists. Some artists feel that with such detailed descriptions of each panel, there is nowhere for them to interject their own ideas. On the other hand, it makes the penciller's work much easier. Time isn't spent in page breakdowns and panel breakdowns. The artist knows exactly what he has to do, and he can spend the time creating the best art possible for the script.

COMIC STRIP FORMAT

Finally, there is the comic strip format of scriptwriting, which is much more rigid than the two previous styles. Daily strips must be precisely written to the point of eliminating almost all questions between writer and artist. This saves a great deal of time. Because many writers live on one side of the country and artists on the other side, keeping scripts in a specific format prevents confusion between the creators and avoids wasted time spent shipping the illustrated "daily" comic strips back and forth for dialogue writing or story corrections. Because of the tight deadlines in the comic strip syndication industry, writers must tell artists exactly what they expect, such as how each panel should look and even how every character appears. Of course, as the artist you can instill your own design ideas and add some flair here and there, but you must know precisely what is expected before you begin drawing.

Because many strip artists letter the strips themselves (or have assistants do it), all the information about the story must be included in the draft of the script that is sent to the artist.

The information on a script for "dailies" (each day's comic strip) goes beyond that of the comic books. You must include the day and date the individual strip will run in the newspaper, the title of the strip and the title of the story.

Presentation of a comic strip script is also special. Because a strip tells a story over a period of several weeks, it can become confusing to the penciller as to which script fits which publication date. To prevent confusion, you must present only one day's worth of story line on each page of the script. Within each day's script, the story is broken into panels, which, except for Sundays, never exceeds four panels. Three is usually the norm.

You must keep a strip's readers interested with short story bursts. Although a comic book can hold the attention of readers for a half hour or longer, a strip only gets a few seconds a day from the readers. Therefore, you must begin each day's story with a quick synopsis of what happened the day before. Only after you've reminded the readers

Sherlock Holmes
"The Man With The Twisted Lip"
Week Eight
Monday, April 19, 1993

1)	Holmes and Watson are in a handsome cab driving along the country side.
Caption:	At dawn the next morning...
Watson:	YAWN. Holmes, why are we out so early this morning?
Holmes:	I want to test a theory of mine.
2)	Riding along.
Holmes:	My dear Watson, you are now sitting in the presence of one of the most absolute fools in Europe! I deserve to be kicked from here to Charing Cross.

Sherlock Holmes
"The Man With The Twisted Lip"
Week Eight
Tuesday, April 20, 1993

1)	Holmes and Watson are in a handsome carriage on their way to the inspector.
Watson:	What are you so irate about, Holmes?
Holmes:	The key to this whole affair, Watson.
2)	They continue.
Watson:	And where is it?
3)	Close up of Holmes holding a large black bag.
Holmes:	It is here! In this Gladstone bag. I have taken it from the bath-room this morning. Come on, my boy, and we shall see whether it will not fit the lock.

Above is an example of two scripts in comic strip format. See page 124 for the finished comic strips.

of the previous day's events can you continue the story. Then you want to keep the readers guessing by ending each day with a cliff-hanger. Make the reader ask himself, What will happen tomorrow? Only then will you be confident that the reader will continue the next day. It is difficult to end each day suspensefully, but, with practice, it can be done.

WRITING GUIDELINES

Before you start writing a script for a particular company, find out what its requirements are so you don't do a great deal of inappropriate writing. Most companies have guidelines for writers, as well as artists, and will send them to you if you provide a self-addressed, stamped envelope with a letter of request.

SCRIPTS AND PAGE COUNT

A script is written for a comic book that will have an average of twenty-two illustrated pages. It doesn't matter how long the typewritten script is, as long as it fits within the length of the finished comic book. Some comic books may be longer than twenty-two illustrated pages, and some may be shorter. It is all up to the editors. However, when you submit a script for review by an editor, you should keep it within the bounds of twenty-two illustrated pages.

PLOT WRITING

Now that you know how to format your script, you can begin working on your plot. Every plot must have a beginning. That is simple. Just

start a story. Some form of a conflict must evolve throughout the story. A conflict can be physical between two (or more) characters, it can be in the mind of one character or it can be between a character and something else. The conflict is usually good versus evil. The conflict starts off small and builds up until the entire situation explodes into the main point of your story, which is called the climax. The climax is usually close to the end of the story. It is where the conflicts get resolved, one way or another. Then you have a slow calming down from the climax, and that becomes the ending.

These story elements pertain to all forms of comic writing. In comic books, it is easier to see each one take place because it happens as you read the entire story, while in comic strips, you don't notice all

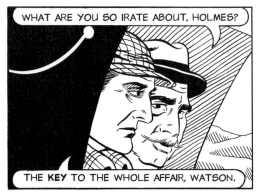

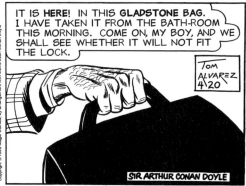

Here you see two consecutive days of an adventure comic strip script. Notice how much the artist put into the final comic.

the story elements as easily because it takes a number of weeks for a story in a comic strip format to end.

DEVELOPING IDEAS

A simple but effective way to develop story ideas is to brainstorm with another creative person. This can be an artist or another writer, or just a friend who has a good imagination, but someone who can take a fresh look at your idea and quite possibly input something that will spark a stronger subplot to your story. More than one mind on a story can only help.

You must know when to stop developing an idea. If your ideas begin to seem corny or completely unbelievable, return to your original, more solid ideas. Study the plots in existing comic books or strips to understand how plots and subplots work. For adventure comic strips, read a collection of strips where a complete adventure story is told. Stay away from humorous comics that do not tell ongoing stories.

ACTION

Action is the name of the game! This is the whole reason readers read comics. They want to read about things they could never possibly do but wish they could. It's

very important to have a substantial amount of action in your story. When the readers get excited about what will happen on the next page, they become even more excited about what will happen in the next book (or next day's strip). But you must also try to keep your stories believable.

Showing action involving your main character is a much better way of describing that character's abilities than telling the reader what that character can do. It also eliminates a great deal of reading for the readers.

DIALOGUE WRITING

You must get the point of the story across with as few lines of dialogue as possible. Dialogue, in comics, takes up too much room. If you put excessive dialogue between two people, whether they are simply talking or in the middle of an all-out war, there will be very little room within that group of panels for the artwork. Lettering can clutter up a panel very quickly. All comic readers want good stories with minimal words and lots of artwork.

KEY QUESTIONS

Before you actually begin to write, think your story idea through a few

times. Ask yourself these questions: Should the story have a moral? Will the story be geared to a certain age group or a universal audience? Should it have a final ending or carry over to the next book? Will it simply be a beat-up-the-next-guy type of story with nothing but violence, or will it be a meaningful, good over evil plot? And the most important question: Will it sell in today's market?

DESIGNING CHARACTERS

After you have answered these questions, design your characters, their abilities, attitudes and appearances and begin working on your plot. It's a good idea to know what your characters' "powers" are before you begin writing. This will help you write smoothly without having to sit back and think about what the characters are able to do. Hesitating could cause you to lose a good moment in the story over a detail you should have known. You can give your characters any imaginable ability or put them in any environment you like, but, most important, make it believable, no matter how far-fetched your story is.

I once had a conversation with Don Perlin at Marvel Comics. I

KEEP IN MIND

- As a young writer, you would be wise to not tell the penciller how the pages and panels should be drawn unless you have a very good understanding of composition and visual storytelling.

mentioned to him that I was disappointed that whenever Bruce (or David) Banner transformed into the Hulk, all his clothing ripped, but he still retained a thirty-six-inch waistline. His reply to me was one of annoyance. Don said, "You accept the fact that a human being could change into a giant, green creature, but you can't accept the fact that his pant waist doesn't rip." I then realized that I was picking at the smallest trifles because the story was written so believably. If you're careful, you can make your readers believe anything.

A good way to convince your readers of just about anything is by placing the story in a setting the reader can relate to, even if the reader was never there. By good descriptions (and good artwork) the reader could believe there really is a colony of humanoids living on Mars. It is all up to you, the story-teller. This is known as establishing the background.

WRITING THE SCRIPT

Start by breaking your story down into separate pages for a comic book, or days for a strip, and then into individual panels with the dialogue included. Shave off unnecessary information and dialogue while you polish the story line. It's a lot to do at the same time, but it becomes second nature after a while.

When you are finished, you should have a good-quality script that is ready to go to any artist, beginner or professional.

As you practice, your writing abilities will improve just as much as your story lines. In time you will modify the method I explained to fit with your working style.

ADDING SUBPLOTS

After you have gained some experience writing simple but exciting stories, make them more complex by adding subplots. Subplots are smaller stories that are told through the main story. For example: If your story is about Incredible-Man who is saving the world from the evil Under-Grounders, he may at the same time be thinking about the problems he is having with his girlfriend back on planet Xecton.

This approach adds more interest and believability to your story because it makes the hero a little more vulnerable—just as we are. And making the readers think the heroes are just like them makes them feel more like the heroes. That makes for a good story.

KEEP IN MIND

• My idea for the best approach to writing a good script is to completely write your plot first. Make it as long and detailed as you want. Establish the background, develop your characters, cause a conflict, stick in some comic relief if you feel it is appropriate and solve a problem. When you are happy with the story, transfer it from a short story to a comic script.

Exercise: WRITE AN EXISTING SCRIPT

Select a finished, published comic book, read it thoroughly and type up the actual script for that book in the complete script format, with all the dialogue and scenes that have already been drawn.

Exercise: CREATE A STORY

Create your own story. First write a plot for it, and then write a complete script. Give it to a friend to read to see if he can follow your story.

Exercise: TRANSFORM A STORY TO A SCRIPT

Choose a short story by a famous author, and write a script version of it for a comic book that has twenty-two pages or a daily comic strip that lasts ten weeks (six dailies and one Sunday per week). Follow the script formats described on pages 120-122. Add or remove dialogue where necessary. Give descriptions of individual panel views and scenery suggestions. Complete the script, and have a friend read it over to see if she can follow your story.

Exercise: CREATE A CHARACTER

Create an original superhero character. Make it whatever sex (or creature) you like. Be sure you have thought through all the elements of the character, such as its strengths, abilities, weaknesses, secret identity (if it has one), costume design and so on. Then create a model sheet of that character that shows all different views and positions of the character so you (or any other artist) could refer to it for drawing likenesses and the costume when illustrating a comic book.

CHAPTER TWELVE

PUTTING IT ALL TOGETHER

OK, now that you understand the individual aspects of comic creation, let's jump right into the arrangement of the comic page or strip. A finished comic page or strip may look simple, but a lot of work went into its construction. Let's start with page one.

SPLASH PAGE

Every comic book has a splash page, sometimes known as the title page. The splash page is usually the first page you see inside the book and consists of one large panel. The splash page runs the title of the book across the top of the page, sometimes the title of the story, a credits list of everyone involved in the book's creation and the indicia. The book title area measures approximately three-quarters of an inch. It may be larger or smaller, depending on what is included within the area. The story title runs beneath the book title and uses whatever space is needed without interfering with the artwork. The credits list can be in any shape, form or style so long as it visually complements the comic book. The indicia appear at the bottom of the splash page. They give the subscription, mailing and copyright information and run about one and one-quarter inches deep.

This shows all the parts of a typical splash page of a comic book and where they are placed on the page.

SUPERMAN November 1970. Published monthly by DC Comics, 1325 Avenue of the Americas, New York, NY 10019. POSTMASTER: Send address changes to SUPERMAN, DC Comics Subscriptions, P.O. Box 0528, Baldwin, NY 11510. Annual subscription rate $18.00. Canadian subscribers must add $8.00 for postage and GST. GST # is R125921072. All foreign countries must add $8.00 for postage. U.S. funds only. Copyright © 1970 DC Comics. All Rights Reserved. All characters featured in this issue, the distinctive likenesses thereof, and all related indicia are trademarks of DC Comics. The stories, characters and incidents mentioned in this magazine are entirely fictional. For advertising space contact: Tom Ballou, (212)636-5520.
Printed in Canada
DC Comics. A division of Warner Bros.-A Time Warner Entertainment Company

INSIDE PAGES

The distinctive feature of the inside pages are the storytelling panels. The panels may be any size or shape but are usually rectangular, which keeps the story flowing smoothly. The space that separates the panels and the different elements on the comic page is known as the *gutter*. The gutter is usually one-quarter of an inch wide and as long or as tall as needed. Usually the gutter area is not printed and remains white, but you *can* ink the gutter so it prints black and adds an interesting effect to your book.

Rectangular panels keep the story flowing smoothly.

COVERS

The comic book cover is very much like a splash page except that all the information is contained within the full-page panel. The cover contains the title, issue number, date, CCA (Comics Code Authority) approval (if approved), UPC code (if registered) and whatever teasers, or, as better known in the business, captions, the writer wants to include to inspire readers to buy the book. Remember to leave enough room around your art for all the elements that must be included in the cover design.

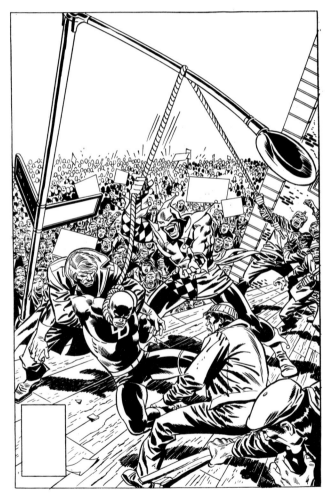

This is what a comic book cover looks like before the titles are pasted down.

This printed comic book cover shows all its parts in place.

PAGE SIZE

All comic book pages are drawn on 11″×17″ paper *within* a working area of 10″×15″. The 11″×17″ size is used because it allows for the large working area and, because of its standard size, makes photocopying of your art easy. The working area is a spacious 10″×15″ so you can draw small details in the panels before the page is reduced down to comic book size. The size of the working area is in direct ratio to the comic book size; when it is reduced to 58 percent, which is standard, it will be the exact size of the artwork needed for printing the finished comic book.

COMIC STRIPS

Comic strips are a completely different animal. Each syndication company has slightly different specifications for drawing strips. Generally, the working area is 3⅞″×13″ with about two inches of extra space all around. Within the working area, the gutters for the panels should be one-quarter of an inch thick, as in comic books.

Panel and gutter lines should be as straight as possible (unless you purposely want them angled). Use your T-square and triangles to ensure parallel lines so your comic looks neat and professional. Haphazard lines will be distracting to your readers. Comic strip readers are very conservative. So don't try anything fancy with the panels, as you could in comic books.

Sunday comics are the most difficult to draw because you don't have any choice about the placement or size of your panels. The syndicate will tell you how it should be. One way of figuring out the size of Sunday originals is to take one from the newspaper and enlarge it until the working area is about 10¾″×16¼″. You may enlarge it more, but it will be difficult and expensive for the syndicates to reduce to newspaper size. I don't recom-

Paper Size 11″×17″

Working Area
10″×15″

For drawing comic book pages, proper paper size is 11″×17″ overall, with a 10″×15″ actual image area.

mend working any larger. Stick to the exact placement of the panels in a Sunday comic strip. This rule is set in stone. The panels must be arranged as each syndicate wants them. Contact each syndicate to learn about its requirements.

KEEP IN MIND

• Each page of the comic book should be photocopied after it has been penciled, lettered and inked. This precaution should become a habit just in case something happens to your originals.

• All the examples shown in this chapter were reduced from their original sizes in order to fit on the pages of this book.

• The measurements given in this chapter for the sizes of comic book pages and comic strips are ex-

act and should be used when creating original comic art, even though the illustrated examples are shown smaller.

• Keep your work clean and smudge free. Always be sure that ink and correction fluid are completely dry before you work on top or directly next to them and *never* have any beverages on the same table you are working on. Horror stories about spillage are numerous.

Exercise:
CREATE A COMIC STRIP

Create four weeks' worth of an adventure comic strip of your choice, again, as above, from script to finished strips. This time, however, you must develop the characters and basic plot of the story. Do not use existing characters for a strip.

Now work the same exercise for creating an entire comic book.

THE COMIC BUSINESS

You have worked long and hard on all the other chapters in this book. Now you are ready to "strut your stuff." But how?

Before you begin to send your work out to different editors, remember that these editors are very busy publishing their magazines or newspapers. They don't have much time to look at your work. However, it's part of their jobs to find new work to publish. Some companies employ editors specifically to look at submissions from new artists.

GETTING FEEDBACK

You must be sure your work is ready for editors to review. By that, I mean be absolutely sure that you are ready for professional cartooning. Praise from a parent or a close friend is nice, but it doesn't hold water in the "real world." You must get honest criticism from people who aren't worried about hurting your feelings; the editors may not be. Find some people who really know about art, such as high school or college art teachers or, better still, professional cartoonists (if you know any) and ask them to critique your work. Take their criticism seriously and constructively; they are helping you more than you can know. Whatever you do, don't take criticism personally. If you do, you are definitely *not* meant to be in this business.

If you have the slightest bit of doubt in your work, or others have told you you need more time drawing, then practice for a few months more. Don't ever rush into submitting your work. First impressions are very important, and if you send your work to editors before you are ready, they will get to know you as one who's not good enough to be published. So take your time and practice hard. The comic industry will always be there.

POTENTIAL MARKETS

OK, you have gotten excellent praise from other artists and professionals in the field. It's now time to submit your work!

First things first. Don't choose only one avenue of cartooning. If you do, you will limit yourself too much. There are many forms of adventure cartooning, such as comic books, children's book illustrations, comic strips, novel (book) illustrations and advertising cartooning. Learn about all your possibilities. There are many good books available at the library or your local bookstore that contain lists of companies and editors' names. One particular book is *Artist's & Graphic Designer's Market*, which lists hundreds of companies that publish artwork, from book publishing companies to greeting card publishers. Each listing contains the company's name, editor's name, address, phone number, what type of artwork the company is looking for and, most important, how to submit samples.

CREATING SUBMISSIONS

After you have researched all the avenues to conquer, create new samples that are specifically for submission. Do your absolute best on the artwork. Keep the work clean and crisp. Muddy and dirty artwork will only turn the editors off. Create a different set of samples for each area of cartooning you are interested in. This is very important to do. Submission samples tell a lot about how you work and how good you are. You can't send comic strip samples to a children's book company; they simply don't want to see that.

Each avenue of comic creation has its own set of variables that must be considered when creating submission samples. Our main focus will be on the two major markets for adventure cartooning: comic book publishing and comic strip syndication.

KING
FEATURES SYNDICATE

SUBMISSION GUIDELINES

King Features is always happy to look at new comic features for possible syndication. We believe in the art of cartooning and place great importance on looking at new material. Without exception, every comic strip or panel idea submitted to us is carefully considered.

In order to help you present your work in the best possible light and to help us respond to it more quickly, the editors have put together the following questions and answers:

HOW MANY CARTOONS SHOULD I SUBMIT?
Send 24 daily comic strips. It is not necessary to send Sunday comic strips. If we like your daily comics, we will ask to see sample Sunday pages.

WHAT SIZE SHOULD I DRAW MY COMICS?
Most comic strip cartoonists draw their daily comic strips 13" wide by 4" tall. Most single-panel cartoonists draw their daily panel 7" wide by 7" high, not counting the extra space for the caption placed underneath the drawing.
You can draw larger or smaller than that, as long as your cartoons are in proportion to those sizes.

WHAT FORMAT SHOULD I SUBMIT MY CARTOONS IN?
You should reduce your comics to fit onto standard 8-1/2" x 11" sheets of paper. Write your name, address and phone number on each page. Do **not** send your original drawings! Send xeroxes instead.

WHAT ELSE SHOULD I INCLUDE IN THE PACKAGE OF CARTOONS THAT I SEND?
Your total submission package should include:
1) 24 daily comic strips -- on 8-1/2" x 11" paper.
2) A cover letter -- that briefly outlines the overall nature of your comic strip.
3) A character sheet -- that shows your major characters (if any) along with their names and a paragraph description of each.
4) A <u>RETURN ENVELOPE WITH YOUR NAME, ADDRESS AND POSTAGE ON IT</u> -- without a return envelope and postage we usually won't respond to your submission.
5) A resume, samples of previously published cartoons

and other biographical information on your cartooning career would be helpful, but aren't strictly necessary.

WHO SHOULD I SEND MY COMIC FEATURE TO?
Send your cartoons to: Jay Kennedy
Comics Editor
King Features
235 East 45th Street
New York, NY 10017

I AM UNFAMILAR WITH SYNDICATION. CAN YOU EXPLAIN WHAT A CARTOON SYNDICATE DOES?
First, a syndicate decides which comic strips it thinks it can sell best. Then it signs a contract with the cartoonist to create the strip on a regular weekly basis. But most of all, the syndicate edits, packages, promotes, prints, sells and distributes the comic strip to newspapers in the United States and around the world on an ongoing basis.
In short, a syndicate is responsible for bringing the cartoons from the cartoonist to the public.

WHAT DO YOU LOOK FOR IN A SUBMISSION?
We are looking for comic features that will simultaneously appeal to the newspaper editors who buy comics and the newspaper readers whose interest the comic must sustain for years to follow. We don't have a formula for telling us which comics will do that, but we do look for some elements that we believe people respond to.
First, we look for a uniqueness that reflects the cartoonist's own individual slant on the world and humor. If we see that unique slant, we look to see if the cartoonist is turning his or her attention to events that other people can relate to.
Second, we very carefully study a cartoonist's writing ability. Good writing helps weak art, better than good art helps weak writing.
Good art is also important. It is what first attracts readers to a comic strip. We look to see that your art is drawn clearly and with visual impact. We want our comics to be noticed on a page.
Finally, we look for your ability to sustain a high level of quality material. We want comics that readers will enjoy for years and years.

DO I NEED TO COPYRIGHT MY CARTOONS BEFORE SENDING THEM?
No, it's not necessary, but if you feel safer doing so, you can obtain copyright information by contacting the Copyright Office, Library of Congress, Washington, DC 20559.

WHAT ARE MY CHANCES OF GETTING SYNDICATED BY KING FEATURES?
King Features is the largest syndicate. Each year, it gets more than 6,000 submissions of which three are chosen for syndication.

King Features's submission guidelines give you a good idea of what companies expect of illustrators submitting their artwork to them.

REPRINTED WITH SPECIAL PERMISSION OF KING FEATURES SYNDICATE.

IF I AM A BETTER WRITER THAN AN ARTIST (OR VICE VERSA), WILL THE SYNDICATE MATCH ME UP WITH A PARTNER?

If your work is far enough along that we think it would succeed if only it had a little better art or a little better writing, then the syndicate will attempt to find you a partner. In most cases, however, it is up to the cartoonist to find a partner.

HOW LONG SHOULD I EXPECT TO WAIT BEFORE RECEIVING A REPLY?

We'll make every effort to respond quickly, but at times it may take us as long as six weeks, due to the high volume of submissions we receive.

IF MY COMIC ISN'T ACCEPTED FOR SYNDICATION, CAN YOU STILL CRITIQUE MY WORK?

We receive well over 6,000 submissions a year. As much as we would like to, it is impossible for us to critique all the work we see. Please understand that receiving a form rejection letter from us isn't a negative criticism of your work. It simply means that at the time we saw your work, we didn't feel that newspaper editors would buy your feature.

WHAT ARE THE TERMS OF PAYMENT IF MY WORK IS ACCEPTED?

If your work is accepted for syndication, the proceeds are split 50/50 between the cartoonist and the syndicate. Cartoonists can make between $20,000 and $1,000,000 dollars a year. It all depends on how many newspapers subscribe to your comic strip and how many products are made from your characters.

CAN YOU GIVE ME ANY TIPS TO IMPROVE MY CHANCES OF SUCCESS?

The single best way of improving your chances for success is to practice. Only by drawing or writing cartoons do you get better at it. Invariably the cartoonists whose work we like best turn out to be those who draw cartoons regularly whether anyone sees their work or not.

Another key to success is to read a lot. Read all sorts of things -- fiction, magazines and newspapers. Humor is based on real life. The more you know about life the more you have to write humorously about.

WHAT BOOKS OR MAGAZINES DO YOU RECOMMEND TO HELP ME WITH MY GOAL OF BECOMING A PROFESSIONAL CARTOONIST?

Cartooning - The Art and the Business by Mort Gerberg, published by William Morrow in 1989, gives an excellent overview of the different careers in cartooning.

Cartoonist PROfiles magazine (P.O. Box 325, Fairfield, CT 06430) is a highly informative publication of particular interest if your goal is to become a syndicated newspaper cartoonist.

The Comics Buyer's Guide (700 E. State St., Iola, WI

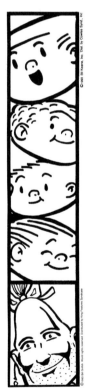

54990) is a thick weekly newspaper primarily devoted to comic book cartooning, but it does have some coverage of newspaper comics. It is a particularly useful publication for those interested in trading, buying or selling old comics strips and art.

Comics & Sequential Art by Will Eisner, distributed by Eclipse Books (P.O. Box 1099, Forestville, CA 95436), is primarily concerned with the creation of comic books and other longer forms of cartooning, but its technical insights into composition, lettering, anatomy, shading and pacing are useful to all cartoonists.

WHAT ARE SOME OF THE COMMON MISTAKES MADE BY ASPIRING CARTOONISTS?

They often place too much emphasis on coming up with a novel character or setting. A strip starring a giraffe won't get critical acclaim just because there's never been a giraffe strip before. Humor is the most important element of successful comic strips, followed closely by well-defined and interesting characters.

In many cases, aspiring cartoonists develop too narrow a premise. Syndicated comics are meant to last for decades. A cartoon about a character who always falls asleep at the wrong time or talks about just one topic day after day, will quickly get repetitive and boring. Develop characters and situations that will allow you many avenues for humor in the future.

Very few aspiring cartoonists pay enough attention to their lettering. The words need to be lettered neatly enough, and large enough, that readers can read them without difficulty.

Newspapers usually print comic strips about 6-1/2" wide. They usually print single panel cartoons 3-1/8" wide. Have your local copy shop reduce a few of your cartoons to printed size to see if your lettering is still legible when reduced.

There shouldn't be too much writing either. People prefer reading shorter, quicker-paced comics.

Many aspiring cartoonists don't use waterproof drawing ink to finish their drawings. Pencils, ballpoint pens, and most felt-tip pens don't reproduce well enough for syndication. Aspiring cartoonists should learn how to use pens and/or brushes with waterproof drawing ink.

Finally, many aspiring cartoonists develop comics that are too similar to already successful strips. Newspaper editors aren't going to duplicate a comic that they already print.

HAS KING FEATURES SYNDICATE MERGED WITH NORTH AMERICA SYNDICATE?

Yes, King Features is made up of several previously independent syndicates. It includes Cowles syndicate and North America Syndicate, which was formerly called News America Syndicate.

Since your work is reviewed by the editors of all these syndicates, you need send only one copy of your proposed comic feature for consideration by King Features, Cowles and North America Syndicates.

COMIC BOOK PUBLISHING

When submitting comic book samples, submit only samples of the type of work you want to do. If you want to be a penciller, submit penciling. If you want to be a letterer, submit lettered pages. Don't try to do everything. It only looks bad for you. Whatever you decide to submit (usually your strongest attributes), do your best.

PENCIL SAMPLES

When submitting penciled work, be sure you have at least four consecutive pages of completed pencils. This lets the editor see not only the quality of your artwork but (what they sometimes consider more important) your storytelling ability. Don't try to be too fancy with a new "style" or extravagant backgrounds. If you can, create pencil samples of a story or script written by a professional writer. There is no reason why you can't send the same set of samples to multiple publishers. Just be sure you are sending comic book samples to comic book publishers and not comic strip syndicates. Publishers want to see if you can draw and tell a story. Never send pinup samples to comic book publishers. A pinup is a single sheet of paper that shows only one scene and typically one main character taking up most of the page. A pinup can include more than one character and usually has an elaborate background. Pinups don't tell editors anything about your ability as a comic artist and storyteller. A pinup only says whether you can create comic book *cover art*, and this area has fewer job openings than illustrating the books themselves.

INKING SAMPLES

If you are sending inking samples, contact the company and request photocopies of professionally penciled pages. The company will do this, but it might charge a small fee for the paperwork and postage. It is better for you to ink over professional pencils than it is to ink over your own work. If the work sent to you is in black and white, lay a sheet of vellum over it and ink on the vellum so you can see only your inked lines. This shows your work better. Some companies will send you photocopies of penciled comic pages that are in non-repro (nonreproducing) blue lines. In this case, you can ink right on top of the blue lines. When you copy the pages to send as samples, the blue doesn't reproduce.

LETTERING SAMPLES

Lettering samples don't have to be done on comic pages as long as you prove you are able to create many different types of special effect letters as well as standard dialogue lettering. Include a variety of balloons around your dialogue samples.

COMIC STRIP SYNDICATION

A syndicate sells your work for you. If you sell a comic strip to a syndicate, it, in turn, tries to sell the strip to every newspaper in the country or the world, depending on how big the syndicate is. The syndicate then collects publication fees and pays you a portion of the fee. It's kind of like having an agent.

Look at the actual submissions guidelines from King Features Syndicate on pages 136-137. The guidelines provide all the information you need to submit a comic strip idea to this syndicate. Although many other syndicates use very similar guidelines, it is best to check directly with a syndicate about its submission requirements.

OTHER MARKETS

Book and magazine publishers are viable markets for your adventure illustration. As with comic book publishers and syndicates, you must find out what book publishers (trade and children's) and magazine publishers need and what their submission requirements are. Again, *Artist's & Graphic Designer's Market* is an excellent source for this information.

In general, magazine editors prefer to see pinups (described above) because there simply isn't room for a story illustrated in comic book format. Children's book illustration is similar to comic book illustration, except that each piece of art is like a splash page; you must follow the story but you don't tell it in multiple panel form. Trade book publishers typically buy single illustrations also, since text is dominant in these "adult" books.

PREPARING A SUBMISSION PACKAGE

Now that you have all of your submission samples ready, make good photocopies of them to mail to the editors of your choice. Never send original artwork; you will probably never get it back. Besides, you can use the originals over and over again for submitting to other companies. Put your name, address and telephone number on every sheet of paper. Many times artists' samples get sent to different editors in the same company, and if the pages are separated (even if you stapled them together), your name is still available to any editor who might take an interest in your work.

Good samples and a well-written, professional cover letter should make up your submission package. A typed cover letter tells

a little something about yourself. Keep it short and to the point, and never sound like a comic fan. If you are sending samples to an editor, she already knows you want work, so don't be crude in your letter by saying, "Do you have any work for me?" Sound professional. For example, "I am very interested in illustrating books for your company." The editors will get the message. Your work is professional. You should be, too.

If you state in your cover letter that you will call the editor in a week to ten days to be sure he received your package, make sure you do. This is a good opportunity to talk with the editor and get quick feedback on your work.

Along with your cover letter and samples, always include a self-addressed, stamped envelope (SASE) for the editor's reply. If you wish to have your submissions back (usually unnecessary because you sent photocopies and you want the editor to keep them on file for possible future review), send an envelope large enough for their return, along with sufficient postage.

One last important item to remember when submitting through the mail is to always send a neat package. If your samples are photocopied on 11" × 17" paper, fold them only once in half, attach the SASE and the cover letter with a paper clip and mail them in a 9" × 12" envelope. Be sure to secure it well, but don't overdo it.

Be warned. You won't get an answer the next day. It usually takes about six to eight weeks to get a response to your submissions, and most of the time the response will be a form letter. Sometimes the letter will suggest how you can improve your work. As I said before, take criticism seriously, and send samples again to that company a few months later. This is a good practice because the editor repeatedly sees your name and becomes familiar with it. With this, your chance of getting work grows.

If you could possibly get an appointment with an editor to view your work in person, do it. That always helps, but don't hold your breath. Editors are much too busy to see everyone who wants to draw for their companies, so don't force the issue. Besides, most of the companies are located in major cities, such as New York, and you might live in Florida or Kentucky, so getting a personal appointment is out of the question anyway.

KEEP IN MIND

• This is a business. Don't ever be embarrassed to talk about money. If a company is interested in using your services, it will expect you to talk about money. If the company is reputable, it will be fair. Remember, you are a professional now, so act it when it comes to business. Take the company's advice (if offered), and make up your own mind. There are many horror stories of how artists have gotten the "short end of the stick" from companies. Try not to let that happen—be aware and knowledgeable.

• You are unlikely to become rich in this line of business, so don't work in comics because you think you will become another Frank Miller. It only happens to one out of hundreds of thousands.

• You are only one of thousands of people trying to get work in this business. Some are better than you, and some are not. Just be as professional as possible, and do your best work.

Exercise:
SUCCEED

For this chapter, you only have one exercise that will (hopefully) last you your career: *Get published!*

BUNNY HOEST DISCUSSES GETTING INTO THE BUSINESS

• "An excellent way to get started is to apprentice to someone who is running a studio and needs a helper," suggests Bunny Hoest, owner of "The Lockhorns." "Just do any job like filling in blacks or cutting paper or doing line-ups (inking in panel frames). Do the actual work to see what the job is like for a person who is responsibly turning out seven strips a week (six dailies and one Sunday). It's a lot of hard work and young cartoonists who are starting should have experience in another studio where somebody needs a pair of hands to do all of the other stuff.

• "In the business of cartooning, it is really necessary to come with experience. Jim Davis, who does 'Garfield,' worked for almost ten years for Tom Ryan, who does 'Tumbleweed.' John Reiner worked for Joe Simon and then Mort Drucker. He then began to do blacks for Bill (Hoest), then a little lettering. When Bill died, John had been with us for years and he knew what to do, so John took over 'The Lockhorns.' The experience in the field is absolutely essential.

• "It is also important for you as a young cartoonist to do your homework. You have to read every comic strip and comic book to know what is out there because you are not going to do a second rate 'Garfield' or a second rate 'Peanuts' or a second rate anything. You must do something that the market lacks. Since

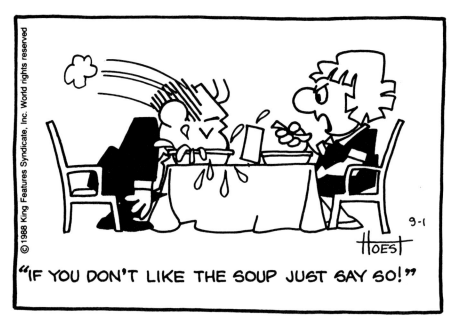

"IF YOU DON'T LIKE THE SOUP JUST SAY SO!"

there are plenty of strips about dogs and plenty of strips about cats, you want to do a strip about what isn't.

• "When you work on comics, don't ever dumb it down. Never insult the intelligence of comic readers. These people are very bright and you want to treat them that way. So write well, and correctly and keep your lettering clean and clear.

• "No matter what you choose to do in comics, make sure you have a backup line of work. Creating advertisements is a good way of keeping in the art field without going broke. A good cartoonist is very flexible. There are great cartoonists doing animation and other forms of cartooning art which happens not to be the area in which they started."

p. 6: Prince Valiant is reprinted with special permission of King Features Syndicate.

p. 19: KARMIKAZE, her likeness and the KARMIKAZE bullet are trademarks of Stephen Price. KARMIKAZE © & ™ Stephen Price 1996.

p. 37: Spider-Man ™ & © 1996 Marvel Characters, Inc. Used with permission.

p. 45: Hedley Kase © Frank Springer.

p. 47: Merlin is © copyright 1996 Michael Morga.

p. 49: Merlin is © copyright 1996 Michael Morga.

p. 50: Merlin is © copyright 1996 Michael Morga.

p. 54: Mary Worth is reprinted with special permission of North America Syndicate.

p. 57: Mary Worth is reprinted with special permission of North America Syndicate.

p. 58: Mary Worth is reprinted with special permission of North America Syndicate.

p. 59: Mary Worth is reprinted with special permission of North America Syndicate.

p. 63: Mary Worth is reprinted with special permission of North America Syndicate.

p. 73: Superman is a trademark of DC Comics © 1995. All rights reserved. Used with permission.

p. 73: Batman is a trademark of DC Comics © 1970. All rights reserved. Used with permission.

p. 75: Hedley Kase © Frank Springer.

p. 76: Merlin is © copyright 1996 Michael Morga.

p. 78: Flash Gordon is reprinted with special permission of King Features Syndicate.

p. 81: Batman is a trademark of DC Comics © 1970. All rights reserved. Used with permission.

p. 82: Archie is ™ & © 1996 Archie Comic Publications, Inc. Used with permission. All rights reserved.

p. 83: Black Panther and Supreme Serpent are ™ & © 1996 Marvel Characters, Inc. Used with permission.

p. 84: Flash Gordon is reprinted with special permission of King Features Syndicate.

p. 84: Supreme Serpent, Hawkeye, Vision, Yellowjacket and Avengers are ™ & © 1996 Marvel Characters, Inc. Used with permission.

p. 87: Incredible Hulk is ™ & © 1996 Marvel Characters, Inc. Used with permission.

p. 92: Superman is a trademark of DC Comics © 1995. All rights reserved. Used with permission.

p. 92: pencil sketch is © copyright 1996, Sy Barry.

p. 93: Flash Gordon is reprinted with special permission of King Features Syndicate.

p. 95: The Phantom is reprinted with special permission of King Features Syndicate.

p. 104: They'll Do It Everytime is reprinted with special permission of King Features Syndicate.

p. 107: They'll Do It Everytime is reprinted with special permission of King Features Syndicate.

p. 120: The Human Torch is ™ & © 1996 Marvel Characters, Inc. Used with permission.

p. 121: Spider-Man is ™ & © 1996 Marvel Characters, Inc. Used with permission.

p. 122: Action Comics Weekly #636 is a trademark of DC Comics. All rights reserved. Used with permission.

p. 130: Superman is a trademark of DC Comics © 1995. All rights reserved. Used with permission.

p. 131: KARMIKAZE, her likeness and the KARMIKAZE bullet are trademarks of Stephen Price. KARMIKAZE © & ™ Stephen Price 1996.

p. 132: Jester and Daredevil are ™ & © Marvel Characters, Inc. Used with permission.

pp. 136-137: King Features' submission guidelines are reprinted with special permission of King Features Syndicate.

p. 140: The Lockhorns are © 1996; WM Hoest Enterprises, Inc.

INDEX

More Great Books for Creating Great Art!